The North American Indians

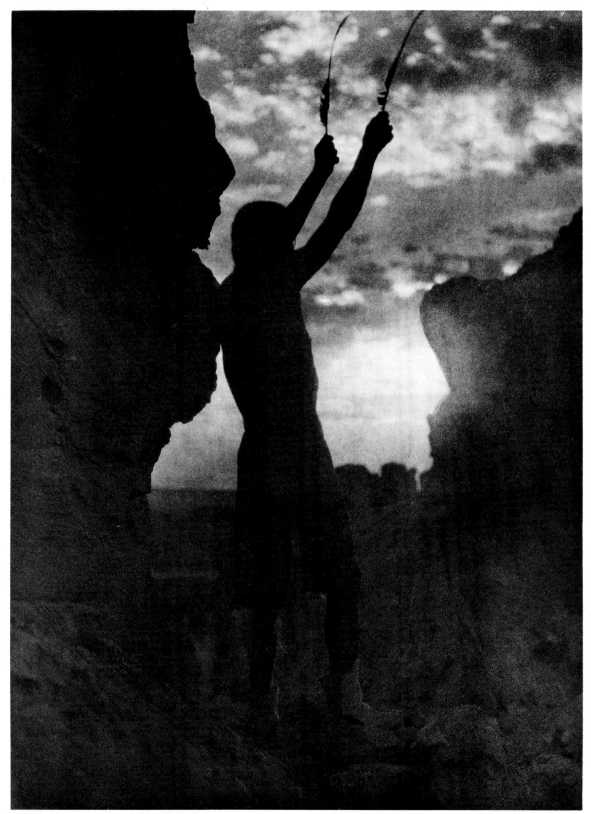

Tewa, *Offering to the Sun, San Ildefonso*

THE NORTH AMERICAN INDIANS

A SELECTION
OF PHOTOGRAPHS BY
EDWARD S. CURTIS

TEXT COMPILED
WITH AN INTRODUCTION BY
JOSEPH EPES BROWN

AN APERTURE BOOK

APERTURE FOUNDATION, INC., PUBLISHES A
PERIODICAL, BOOKS, AND PORTFOLIOS OF FINE
PHOTOGRAPHY TO COMMUNICATE WITH SERIOUS
PHOTOGRAPHERS AND CREATIVE PEOPLE EVERYWHERE.
A COMPLETE CATALOG IS AVAILABLE
UPON REQUEST. ADDRESS: 20 EAST 23RD STREET,
NEW YORK, NEW YORK 10010.

PRINTED AND BOUND IN HONG KONG
BY EVERBEST PRINTING CO., LTD.

COVER PHOTO: LUMMI TYPE,
PHILADELPHIA MUSEUM OF ART: PURCHASED WITH
FUNDS FROM THE AMERICAN MUSEUM OF PHOTOGRAPHY.

PREFACE

In 1896 Edward S. Curtis began the project of recording on film with explanatory text all available information on the Indians of North America. He estimated the task would be completed in about ten years. By 1905 the project had not only not been completed, but Curtis had also depleted his own financial resources, and he sought a patron to assume the financial burden. He was fortunate in enlisting the sympathy and financial support of J. Pierpont Morgan early in 1906, and in that year Curtis resumed his field work with renewed vigor.

Curtis encountered every imaginable difficulty in the following years, but he was able to complete the project by 1930. He made over forty thousand negatives, first using a 14 x 17 view camera, later an 11 x 14, and finally a 6 x 8 reflex camera. Nearly all the photographs were made on glass plates. The final published work extended to twenty volumes of text, each of which was accompanied by a portfolio volume of plates.

The North American Indian was one of the most ambitious books ever undertaken by a single man. Its text is of importance to the scholar of the American Indian and its plates record for posterity what Curtis thought to be a vanishing race.

Forty years after the publication of the last volume of *The North American Indian*, The Pierpont Morgan Library, under the direction of Dr. Charles Ryskamp, presented a major exhibition of the photographs by Edward S. Curtis. This exhibition served to renew interest in his work and inspired both the exhibition in the fall of 1972 at the Philadelphia Museum of Art and this publication. The complete set of Curtis's work at the Philadelphia Museum of Art was purchased with funds generously donated by the American Museum of Photography.

INTRODUCTION
MIRRORS FOR IDENTITY
in The Photographs of
Edward S. Curtis

It is thus near to Nature that much of the life of the Indian still is; hence its story, rather than being replete with statistics of commercial conquests, is a record of the Indian's relations with and his dependence on the phenomena of the universe—the trees and shrubs, the sun and stars, the lightning and rain—for these to him are animate creatures. Even more than that, they are deified, therefore are revered and propitiated, since upon them man must depend for his well-being. Edward S. Curtis

The images projected by Edward Curtis speak with urgency and timeliness. The message is of people and of culture; it is of a multitude of ways of being and living, of acting and interacting, and of qualities of relationship. Across the total collection of text and plates the essential message is of a crisis. It is a crisis not exclusively related to survival of the American Indian and his cultures. It is a more general crisis terribly real for all men today, Indian and non-Indian. The critical problem is not of *a vanishing race*, as Curtis's generation saw it; for we now understand that providentially the Indians as a people are far from vanishing. The problem, rather, is rooted in a continuing and ever expanding process of detraditionalization whereby dimensions of *the sacred* are eliminated from life and from being and acting. No men are immune from the pervasiveness of this process.

The spiritual and aesthetic shock experienced through the Curtis portraits derives from the realization that the qualities reflected here were forged by an age lost to the world of today. From this loss, modern man senses a nostalgia which leads with frantic compulsion in a quest extending in every possible direction. His search, often unconscious, is for something which may give back to life its meaning and purpose.

The quest accelerates through time, for concomitant with the loss of

knowledge as to who man is, is the abuse of his environment—now erroneously thought to be totally other than man himself. In the resulting dehumanization and desacralization of Nature, man experiences suffering in fear. For if men listen to no other teacher, Nature demands that they listen to it; inevitably, it is the Master who must and will have the last word. Approaches to ecological problems which ignore these fundamental concerns will always remain superficial, illusory, and ineffective.

The current renaissance of interest in the American Indian is in large measure related to our own critical concerns. In our search for ourselves we are beginning to look to the American Indian in a manner never attempted before. We wish to know who the Indian was and is, by what values he lived, and the nature of his special relationship with his natural environment. Our hope is that these questions are being asked in sincerity, with real intellectual commitment rather than with just emotional reaction; for, if the search is sincere, it is possible that men may learn from the Indian's legacy and example.

The problem in such a projected dialogue lies in the danger that once again the Indian will be used as he has been in the past. He may not be seen for, nor will it be asked how he became, what he was or is. He may be used, instead, as a mirror in which we conveniently see only what we want to see of ourselves and our personal illusions. Then, rather than finding answers to hard questions which demand a giving up of our illusions, hypocrisies, and favorite comforts, we may engage in the projection of an idle dream world, with the riches of the Indian heritage remaining as inaccessible and as incomprehensible as before.

Those lost qualities of being, reflected with clarity in each personality portrayed by Curtis, and still to be observed and felt in many living Indians, provide eloquent statement about a rich legacy deeply spiritual in essence. We need to know the key dimensions of this legacy and the modes by which such wisdom becomes integrated into human personality.

Aware of these broad considerations, and having experienced the emptiness of an academic world of irrelevant theory, some twenty-five

years ago I sought for an American Indian who might still be a living
example of the traditional values of his people. Eventually, I found Black
Elk *(Hehaka Sapa)*, an old sage of the Lakota, or Oglala Sioux, living
on the Pine Ridge reservation near Manderson, South Dakota. In our
ensuing day-to-day encounters, lasting several years until the old man's

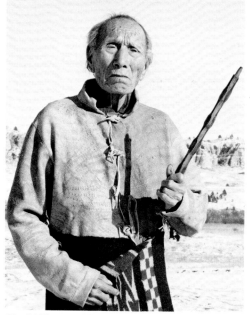

Black Elk, 1947 (Photograph by J. E. Brown)

death in 1950, and leading to my adoption into his family, I learned to
understand how qualities of being could become total, thus *holy*, through
participation in the nourishing force of a rich and demanding
spiritual heritage.

If, as I observed, Black Elk manifested a quality of soul which could
be called *childlike*, it was because for him the state of the child had
become integrated into, not excluded from, the state of the man. He
could laugh and play games and tell stories and relate to little children
as if he himself were a child. When I asked how he understood his re-
lation to children, he replied that he and the little child were very close
in reality; for the child had just come from the Great Spirit *(Wakan-*

Tanka); and he, an old man, was about to return to the Great Spirit. The attitude reflected an integration of being, present not by accident nor by chance; for it was the product of long participation in a total tradition of sacred wisdom accompanied by ritual method.

Purity of body and soul was actualized in the Lakota through the rites of the sweat bath *(inipi)*. In the round lodge where these rites took place, earth, air, fire, and water joined forces to act upon and cleanse the total man. Combined with purity of being and inseparable from it is the state of humility which, it was thought, must be present if guidance is to be received through the sacrificial retreat or lamenting. In purity with humility something of the primordial state of the child can become present in the realized man. This was one aspect of Black Elk perceived by those who knew him.

Where there was in the soul of Black Elk purity and humility there was, at the same time, an expansion of being which finds its outward expression in spontaneous generosity, a prime virtue of the Lakota. His soul and being had become like the totality of the circle of the traditional camp, or as the circle of their dwellings, the Tipi, or like the round purification lodge, or ultimately like the circle as principle which finds its reflection in all the forces and forms of the world. Nature may teach this principle once the secret is known, but without the grace and power of traditional wisdom, such understanding remains inaccessible to man.

Crucial to the actualization of wholeness of being are the many dimensions of a wisdom learned and perpetuated through a deep understanding of all the forms and aspects of Nature to which the Indian was exposed in his environment. When Black Elk told his countless stories about the animals and their little traits and characteristics, I came to understand that he was talking about the deep realities of his religion. In the all important bison, for example, generosity was apparent to Black Elk, for his people filled almost all their physical needs with all that the bison provided: hides for lodge-covers and for clothing, horn and bones for tools and utensils, sinew for thread, and a hundred more

articles from all parts of the animal's body. The bison was an all-giving mother, nourishing the people and, in her special care for her own children, providing an example of a devotion mingled with sacrifice. In this way the bison was eminently sacred, *wakan*, containing in essence the generous all-giving nature of the earth itself.

The four winds of the four directions of space, about which Black Elk often talked as if they were anthropomorphic beings, represented distinctive power which determined the dynamic process and qualitative nature of life. Underlying this concept was the understanding that ultimately these winds were but one wind, unseen in its effects upon phenomena just as the Great Spirit remains unseen but is evident and known through effect upon the forms of the world.

It was from such effects that Black Elk, and the Indians universally, learned the secrets of life, for every aspect of the *outer* world had its counterpart in the soul of man. Underlying all life — man, the animals, birds, forms and forces of the natural environment — were similar sacred meanings.

Where there is actualized a wholeness of person rooted in purity and humility, there is possible the ultimate experience of identity and integrated knowledge of a fundamental unity underlying all the diversity of the world of appearance. For Black Elk, a bird like an eagle was not arbitrarily a symbol of some other or *higher* reality; it *was* that reality manifest. I learned this lesson in a hard way. As many Indians then did, I hunted eagles since I understood in what manner the older Indians valued their feathers for headdresses and plumes, wing bones for Sun Dance whistles, and claws for necklaces. Black Elk appreciated these forms for use in various rites. Yet, one day he said that I should not shoot the eagle; for in reality I was shooting himself. In his frequent vision-encounters with the eagle he had come to identify with all that the eagle represented. He explained: as the eagle flies in a circle, higher than all other creatures, and as he sees all upon the earth below, so he was understood to be, ultimately, none other than the Great Spirit.

This quality of identity, and relatedness to all that is, came to be realized not simply through encounter with the forms of nature, but first and primarily through the supporting power of the traditional values made concrete through the sacred rites and ritual forms. The fire at the center of the tipi, or the central tree at the center of the Sun Dance Lodge as axis of the world, or simply the central point established at the earth-altar of the four or six directions of space, all expressed the concept of a central unity without which space has no meaning.

Purification, expansion, and identity are the key dimension in the structure of Black Elk's world, as indeed they are the key to all legitimate traditions and spiritual ways of the world. Within such a structure, Nature is not understood with the vague and romantic sentimentality which is generally our relationship today. Rather, the messages of Nature for the Indians are so situated within the framework of traditions of sacred origin that they constitute an exacting and complex science, the integral understanding of which, like all real knowledge, demands intense sacrifice.

This was a part of the world of Black Elk. It was the recognition of the loss of this world that gave him the hard sense of destiny to mend in some way *the broken hoop of the nation*, to bring to flower again the sacred tree of life. It was this struggle which gave to his life both tragic suffering and the heroic elements of sacrifice.

This was the kind of world which formed, in varying degrees and with varied expressions, the personalities documented by Curtis with the realism of his camera, tempered by his own creative sensitivity and by insights into his own inner world, which actually was very close to the world of the Indian.

The words of Frithjof Schuon, one of the greatest living exponents of the *philosophia perennis*, provide apt concluding commentary to these qualities of life and being impressed upon the face of Black Elk and upon the subjects of the Curtis photographs.

A fascinating combination of combative and stoical heroism with a

priestly bearing conferred on the Indian of the Plains and Forests a sort of majesty at once aquiline and solar; hence the powerfully original and irreplaceable beauty that is associated with the red man and contributes to his prestige as a warrior and a martyr. Like the Japanese of the time of the Samurai, the Red Indian was in the deepest sense an artist in the outward manifestations of his personality: apart from the fact that his life was a ceaseless sporting with suffering and death, hence also a kind of chivalrous Karma yoga, *the Indian knew how to impart to his spiritual style an aesthetic adornment unsurpassable in its expressiveness.*

One factor which may have caused people to regard the Red Indian as an individualist—in principle and not merely de facto—*is the crucial importance he attaches to moral worth in men—to* character *if you will—and hence his cult of action. The whole Red Indian character may be summed up in two words, if such a condensation be allowable: the act and the secret; the act shattering if need be, and the secret impassive. Rock-like, the Indian of former times rested in his own being, his own personality, ready to translate it into action with the impetuosity of lightning; but at the same time he remained humble before the Great Mystery, whose message he knew, could always be discerned in the Nature around him.* (Light on the Ancient Worlds, *Perennial Books*)

This book, with word and image, mirrors much that we know we are not, yet would be. *Joseph Epes Brown, Stevensville, Montana, July, 1972*

Joseph Epes Brown is a graduate of Haverford College with an M.A. in Anthropology from Stanford University and the Ph.D. in Anthropology and History of Religions from the University of Stockholm. His interest in the traditional beliefs and values of the American Indians led him to Black Elk, with whom he lived for a year recording his account of the seven rites of the Oglala Sioux. He published this account in The Sacred Pipe, *University of Oklahoma Press. He has also published* The Spiritual Legacy of the American Indian, *Pendle Hill. He is presently a professor in the Department of Religious Studies, the University of Montana.*

TEXT AND PHOTOGRAPHS

Perhaps it may be, and this is my prayer that, through our sacred pipe peace may come to those peoples who can understand, an understanding which must be of the heart and not of the head alone. Then they will realize that we Indians know the One true God, and that we pray to Him continually.

We should understand well that all things are the works of the Great Spirit. We should know that He is within all things: the trees, the grasses, the rivers, the mountains, and all the four-legged animals, and the winged peoples; and even more important, we should understand all this deeply in our hearts, then we will fear, and love, and know the Great Spirit, and then we will be and act and live as He intends.
Black Elk, Oglala Sioux

At the beginning all things were in the mind of the Wakonda. All creatures, including man, were spirits. They moved about in space between the earth and the stars. They were seeking a place where they could come into a bodily existence. They ascended to the sun, but the sun was not fitted for their abode. They moved on to the moon and found that it also was not good for their home. Then they descended to the earth. They saw it was covered with water. They floated through the air to the north, the east, the south, and the west, and found no dry land. They were sorely grieved. Suddenly from the midst of the water uprose a great rock. It burst into flames and the waters floated into the air in clouds. Dry land appeared; the grasses and the trees grew. The hosts of spirits descended and became flesh and blood. They fed on the seeds of the grasses and the fruits of the trees, and the land vibrated with their expressions of joy and gratitude to Wakonda, the maker of all things.
The teachings of the Omaha Pebble Society as given by Wakidezhinga, an old leader.

Everything as it moves, now and then, here and there, makes stops. The bird as it flies stops in one place to make its nest, and in another to rest in its flight. A man when he goes forth stops when he wills. So the god has stopped. The sun, which is so bright and beautiful, is one place where he has stopped. The moon, the stars, the winds he has been with. The trees, the animals, are all where he has stopped, and the Indian thinks of these places and sends his prayers there to reach the place where the god has stopped to win help and a blessing.
A Chief of the Oglala Sioux

O our Mother the Earth, O our Father the Sky,
Your children are we, and with tired backs
We bring you gifts you love.
Then weave for us a garment of brightness;
May the warp be the white light of morning,
May the weft be the red light of evening,
May the fringes be the falling rain,
May the border be the standing rainbow.
Thus weave for us a garment of brightness,
That we may walk fittingly where birds sing,
That we may walk fittingly where grass is green,
O our Mother the Earth, O our Father the Sky.

Tewa, *Song of the Sky Loom*

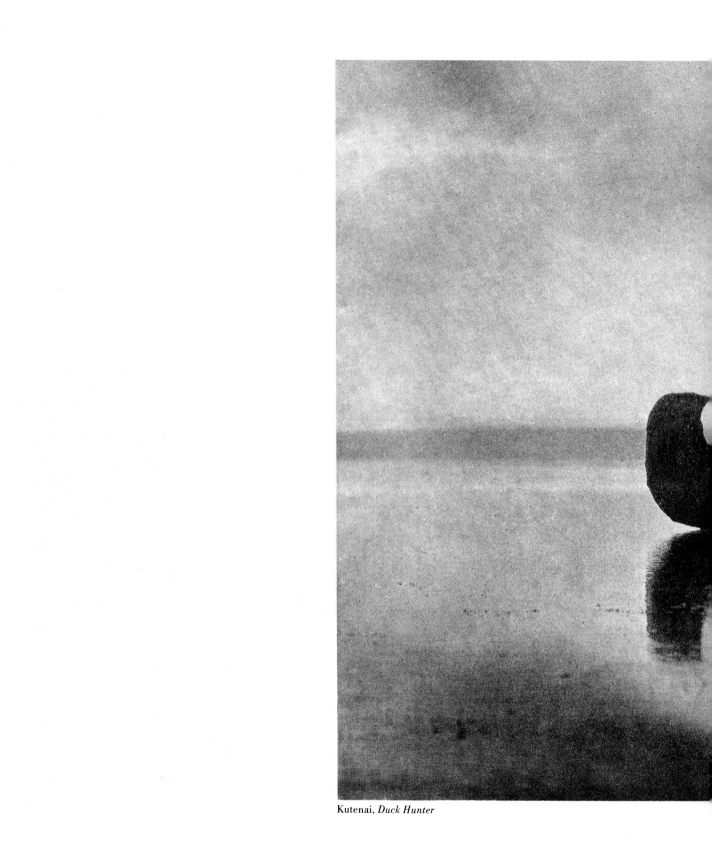

Kutenai, *Duck Hunter*

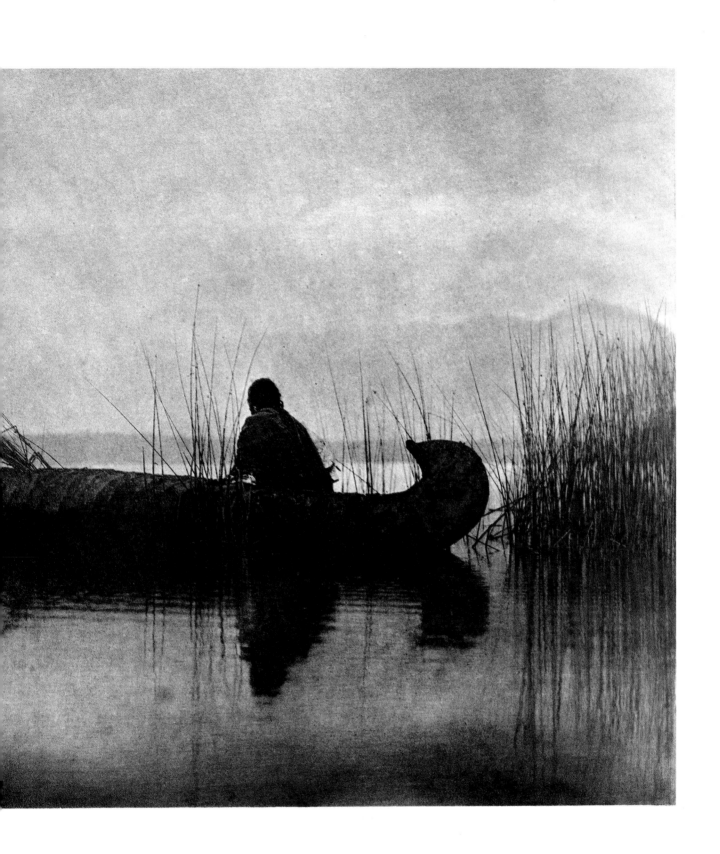

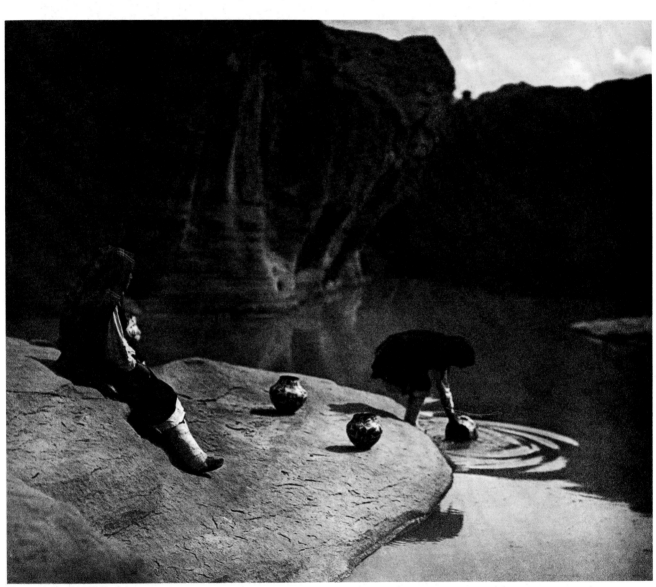

Keres, *At the Old Well of Acoma*

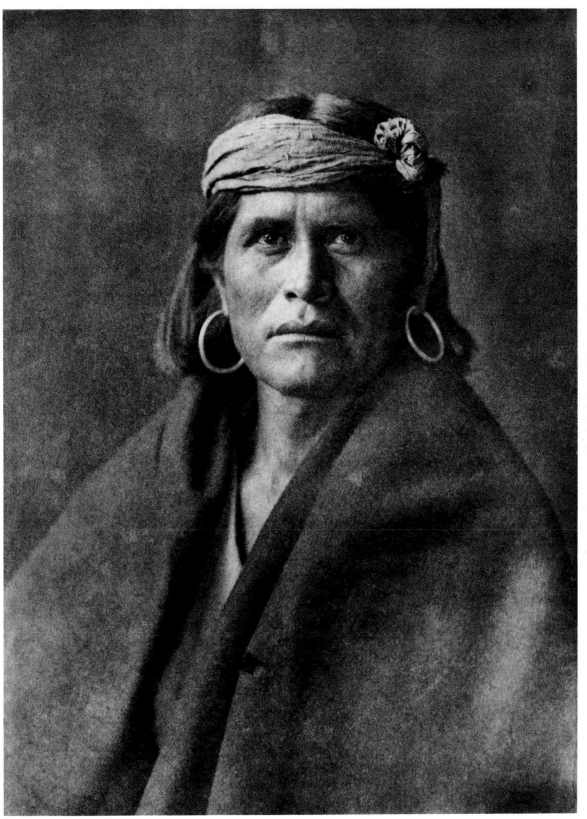

Hopi, *A Walpi Man*

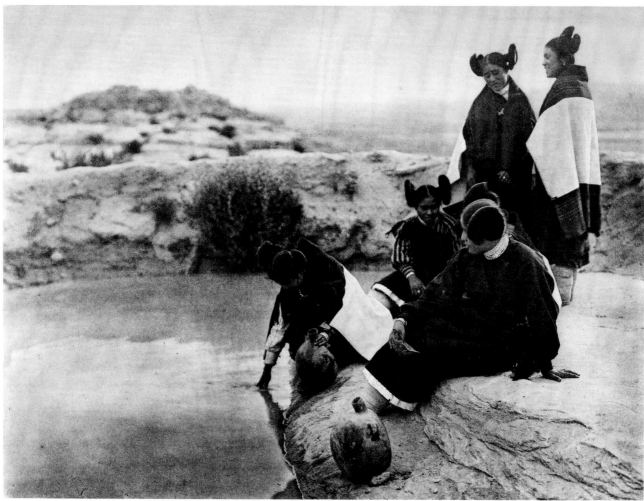

Hopi, *Loitering at the Spring*

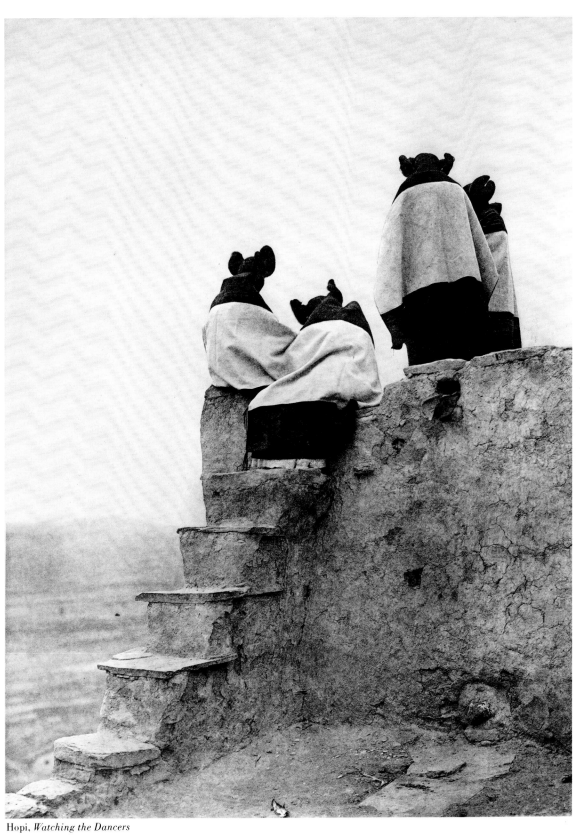

Hopi, *Watching the Dancers*

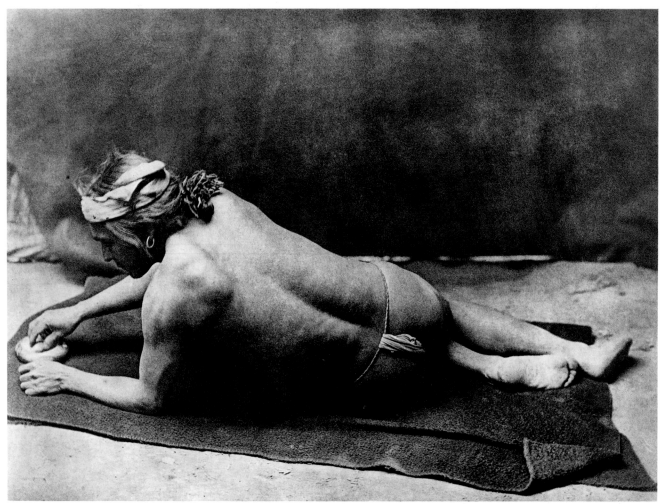

Zuni, *Grinding Medicine*

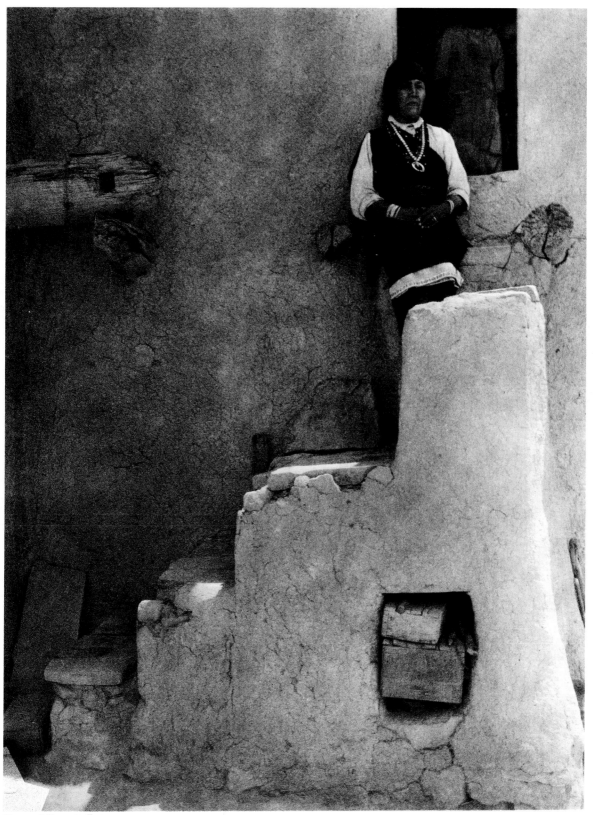

Keres, *A Paguate Entrance*

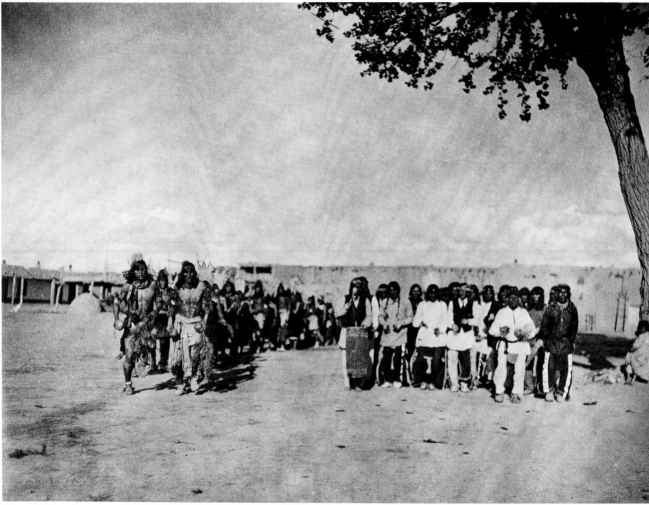

Tewa, *Tablita Dancers and Singers, San Ildefonso*

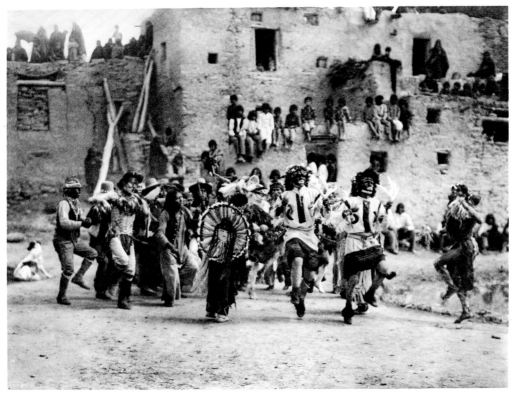

Hopi, *Buffalo Dance at Hano*

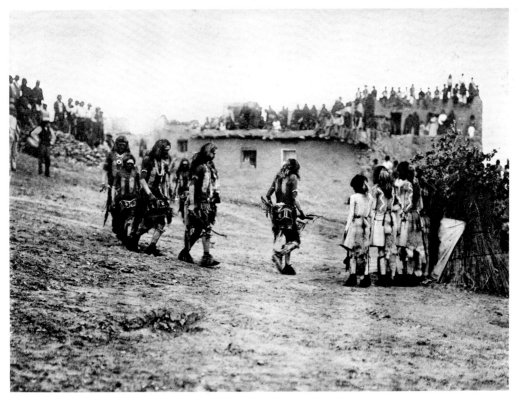

Hopi, *Snake Dancers Entering the Plaza*

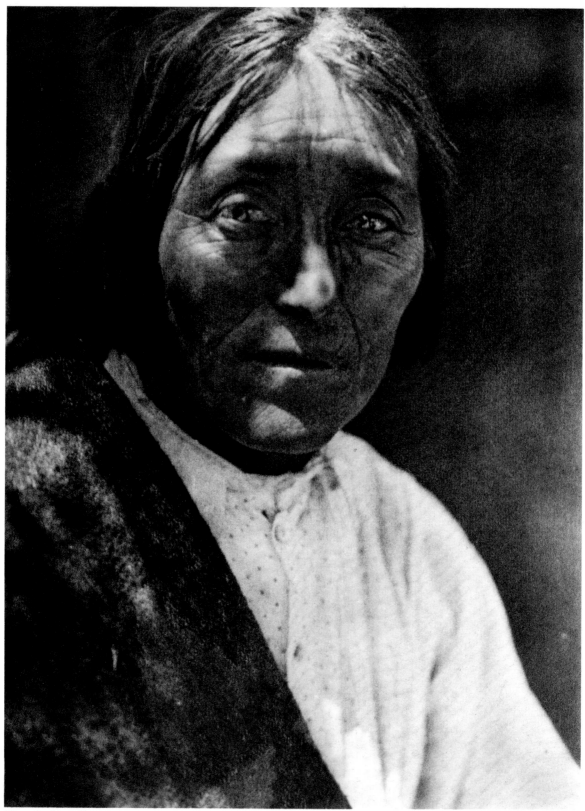

Tiwa, *An Isleta Man*

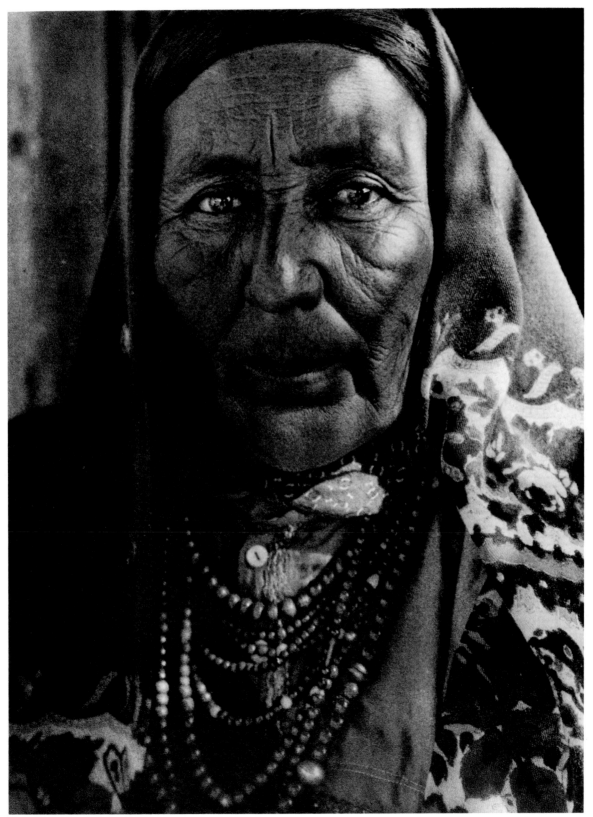

Tiwa, *Francisca Chiwiwi, Isleta*

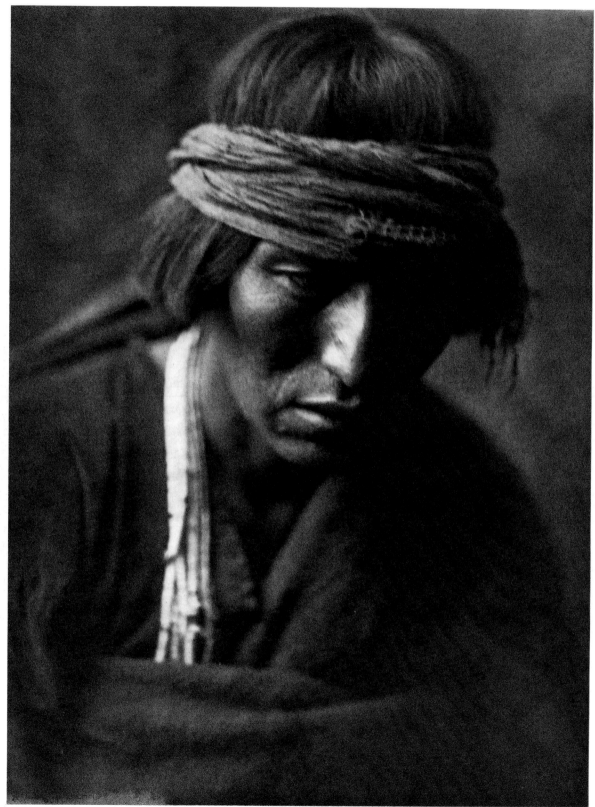

Navaho, *Medicine Man—Hastobiga*

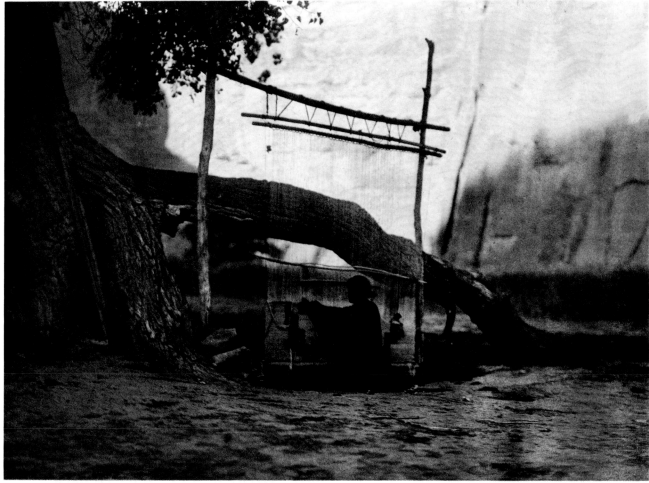

Navaho, *The Blanket Weaver*

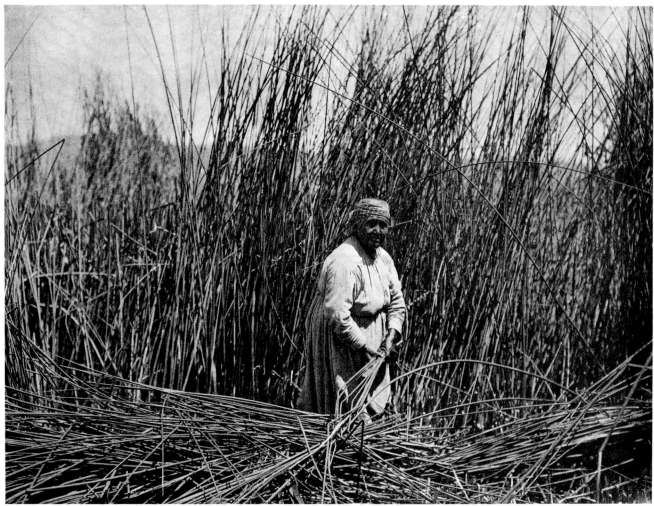

Pomo, *Gathering Tules*

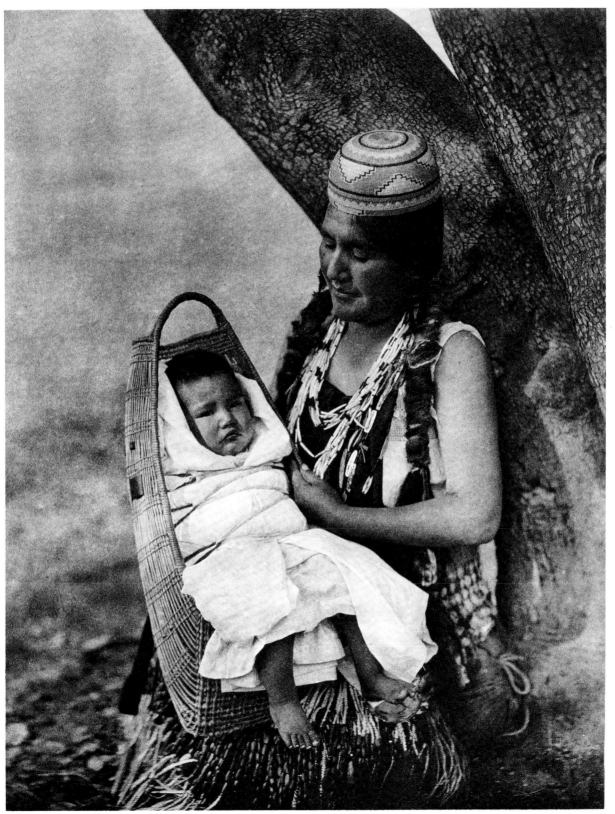

Hupa, *Mother and Child*

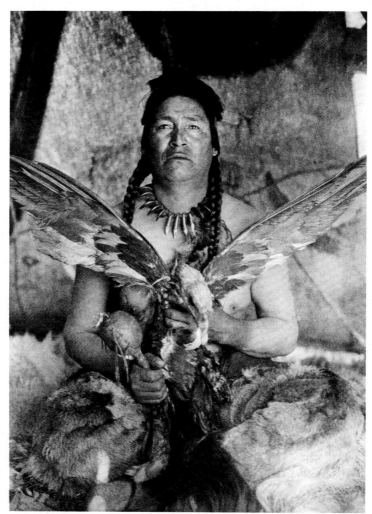

Assiniboin, *Placating the Spirit of a Slain Eagle*

If men would...seek what is best to do in order to make themselves worthy of that toward which they are so attracted, they might have dreams which would purify their lives. Let a man decide upon his favorite animal and make a study of it, learning its innocent ways. Let him learn to understand its sounds and motions. The animals want to communicate with man. Brave Buffalo, Teton Sioux

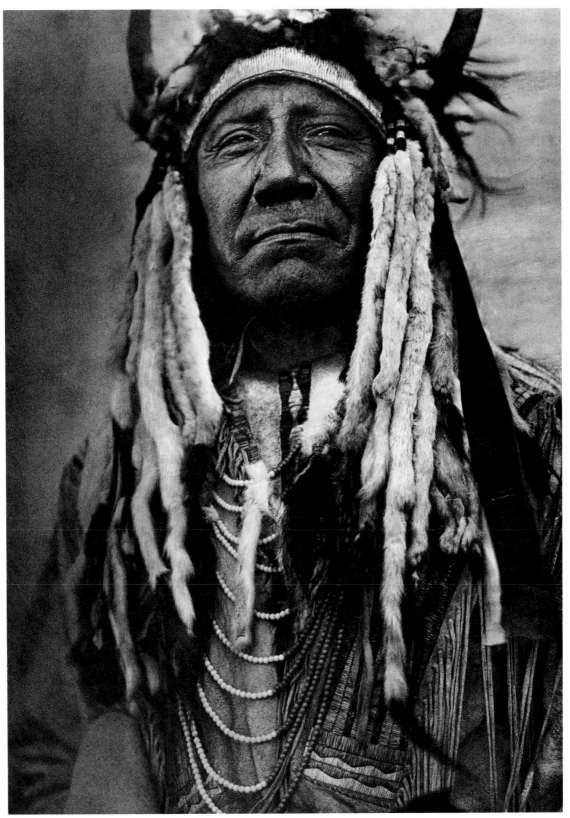

Cheyenne, *Two Moons*

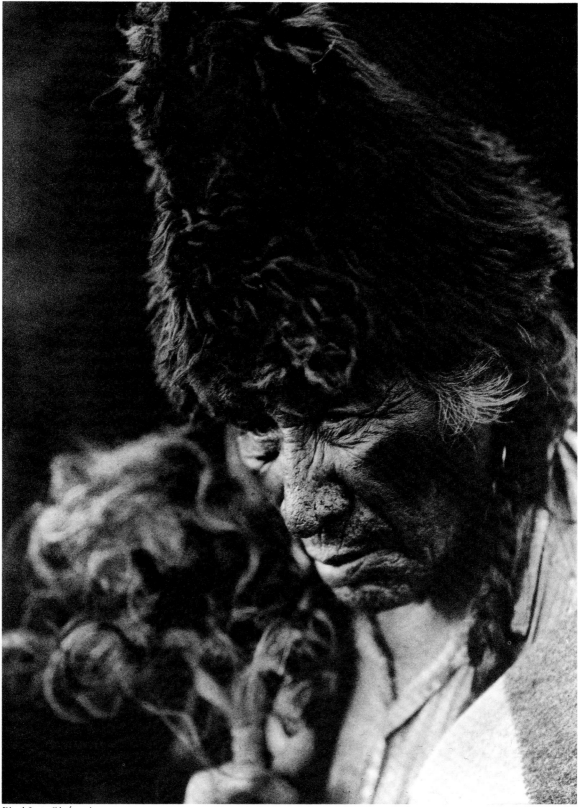

Blackfoot, *Oksóyapiw*

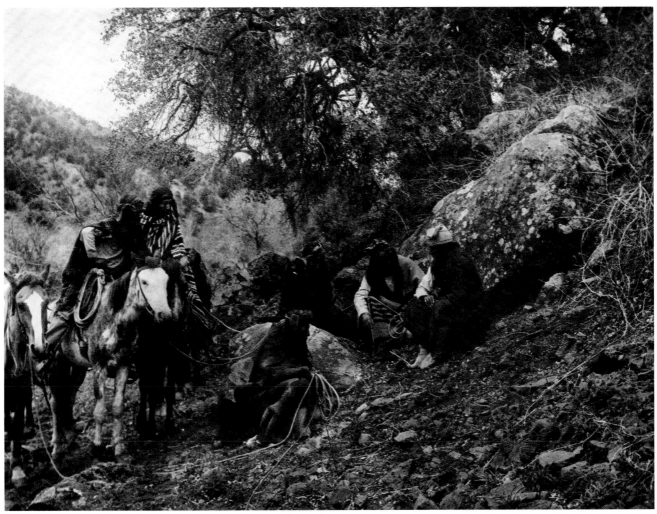

Apache, *Story-Telling*

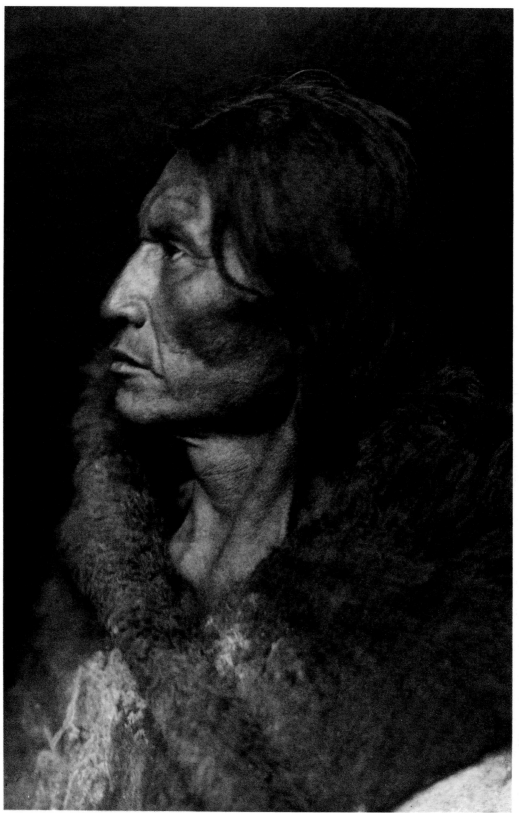

Assiniboin, *Mosquito Hawk*

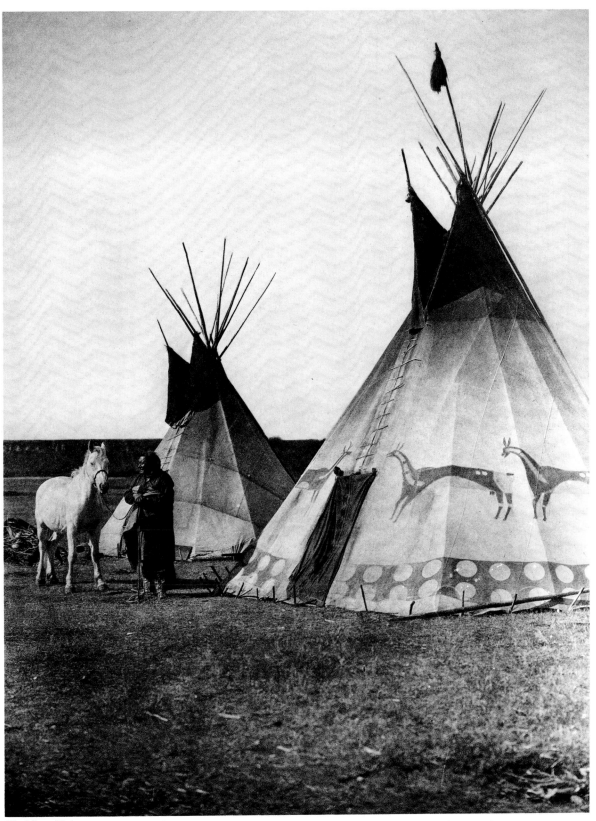

Blackfoot, *Tipis*

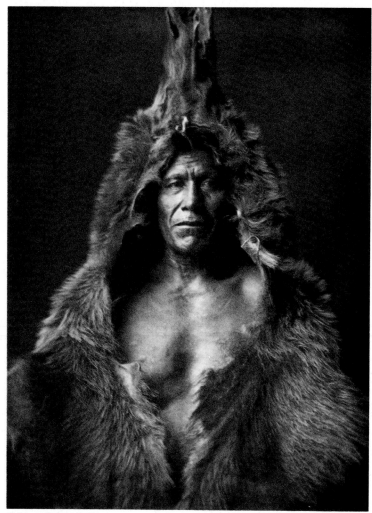

Arikara, *Bear's Belly*

*...the characteristics of a bird or an animal were desired by the Indians
who, in some cases, wore a part of the bird or animal on their persons;
the deer, because this animal can endure thirst a long time; the hawk as
the surest bird of prey; the elk in gallantry; the frog in watchfulness;
the owl in night-wisdom and gentle ways; the bear, which though fierce,
has given many medicinal herbs for the good of man; the kit-fox, which
is active and wily; the crow, which is especially direct as well as swift
in flight; and the wolf, in hardihood.* Frances Densmore

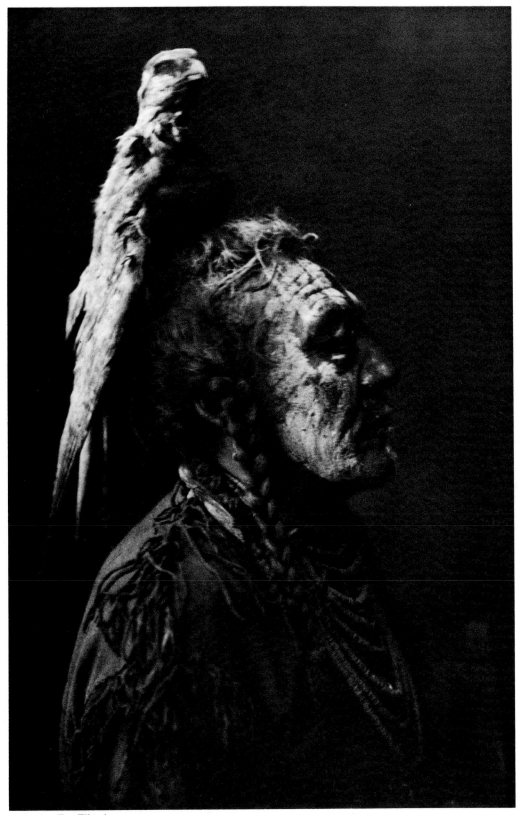

Apsaroke, *Two Whistles*

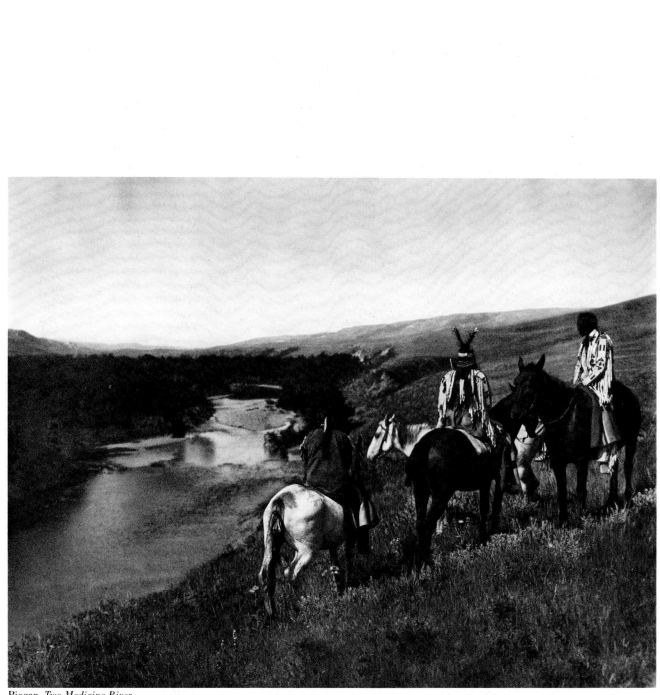

Piegan, *Two Medicine River*

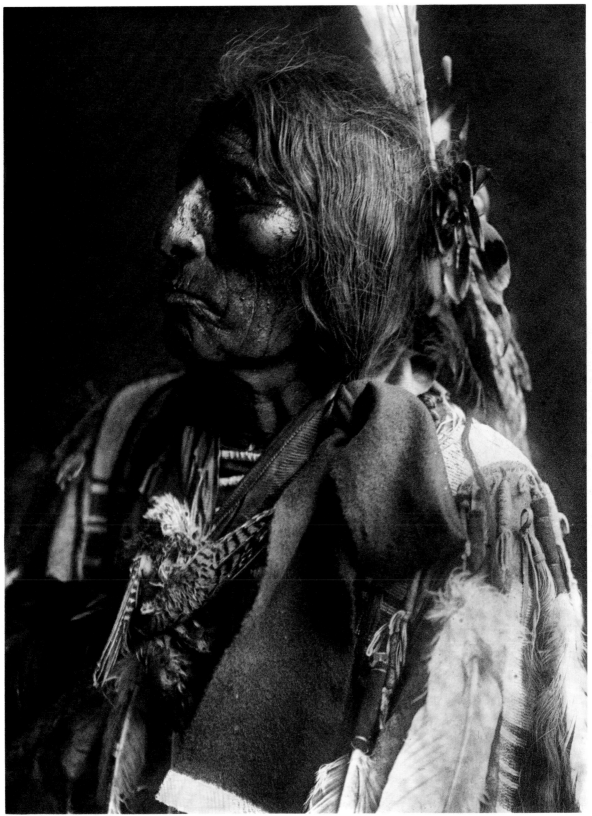

Oglala Sioux, *Slow Bull*

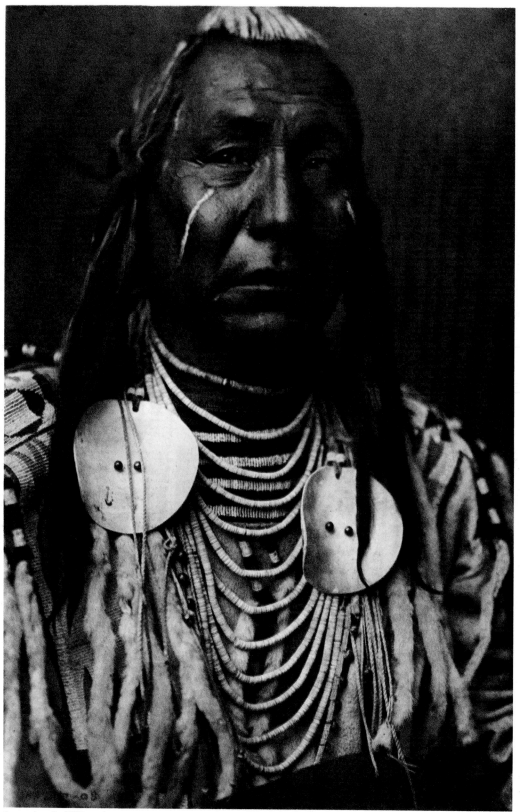

Apsaroke, *Red Wing*

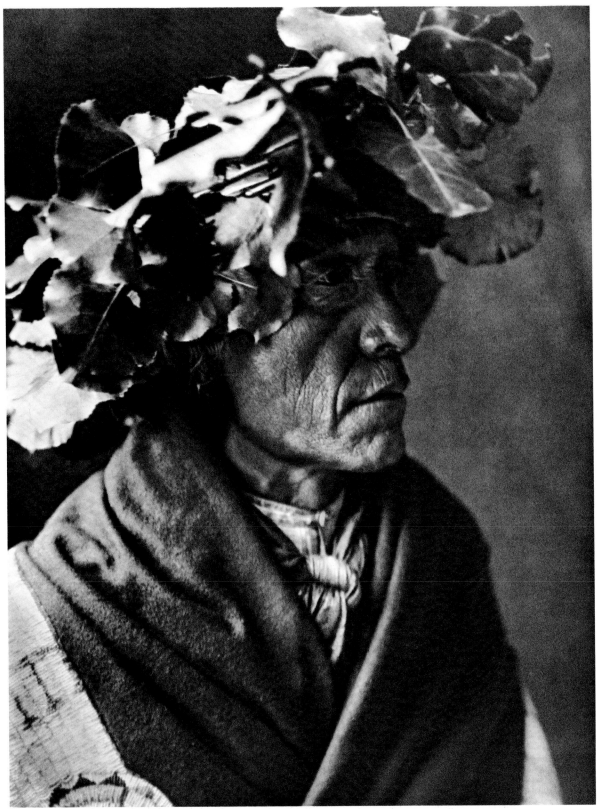

Cheyenne, *Porcupine*

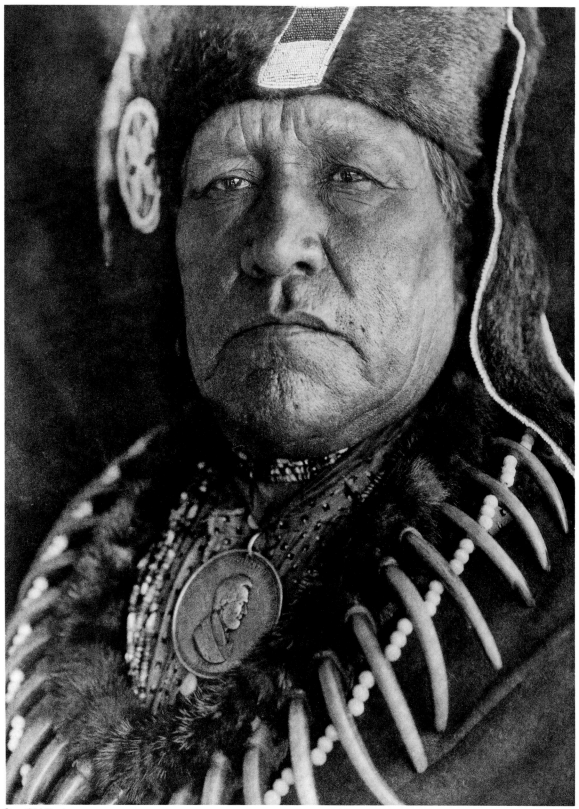

Oto, *Old Eagle*

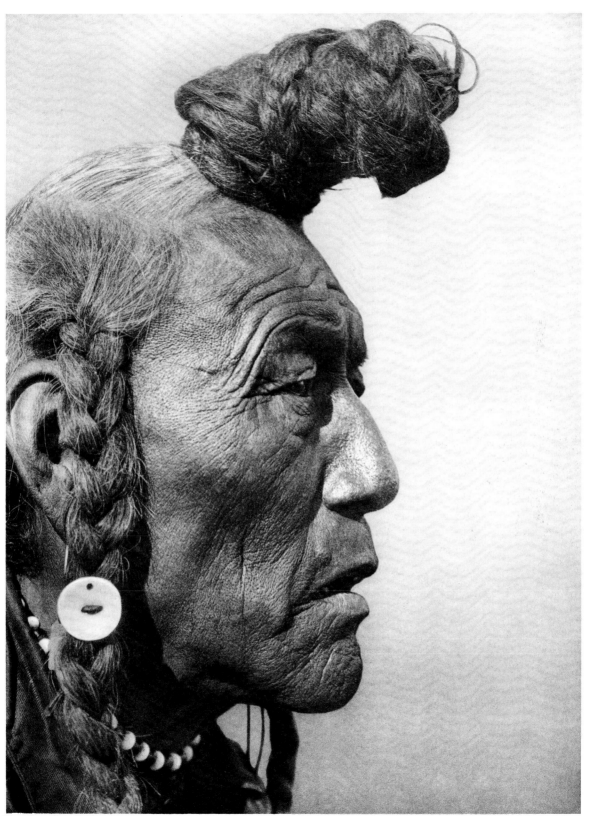

Blackfoot, *Bear Bull*

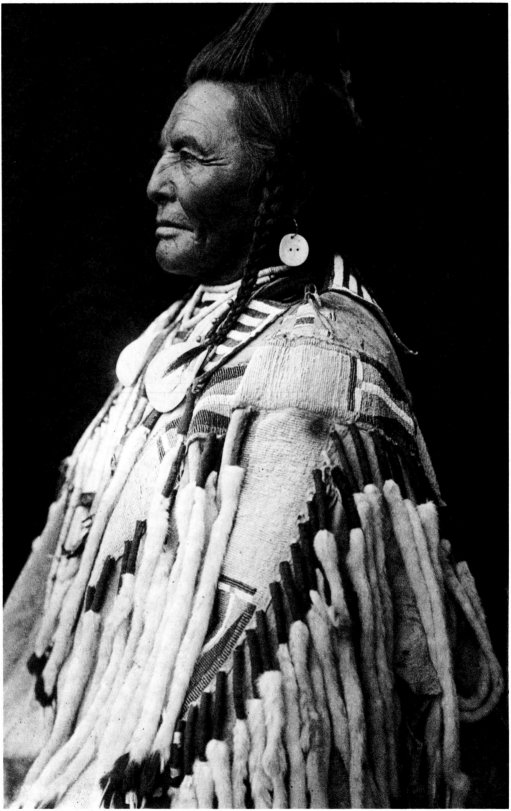

Apsaroke, *Shot in the Hand*

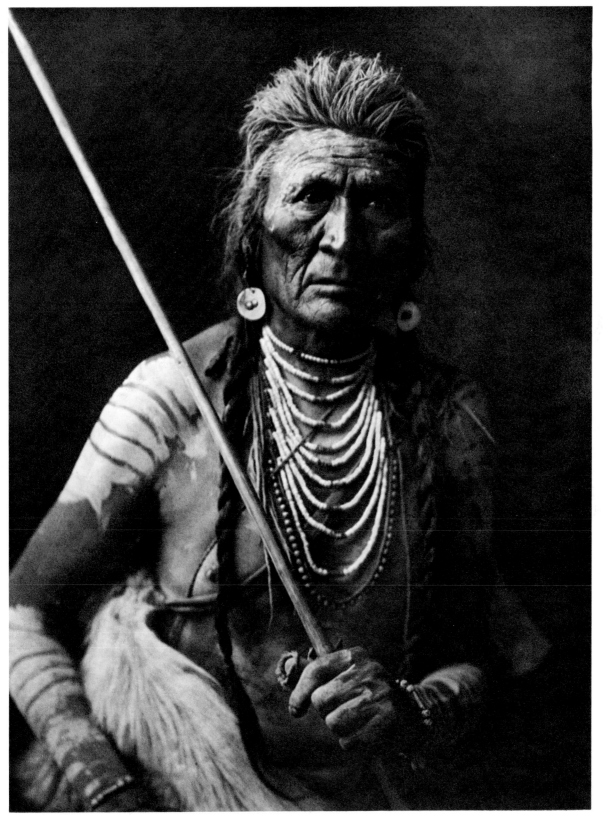

Apsaroke, *Wolf*

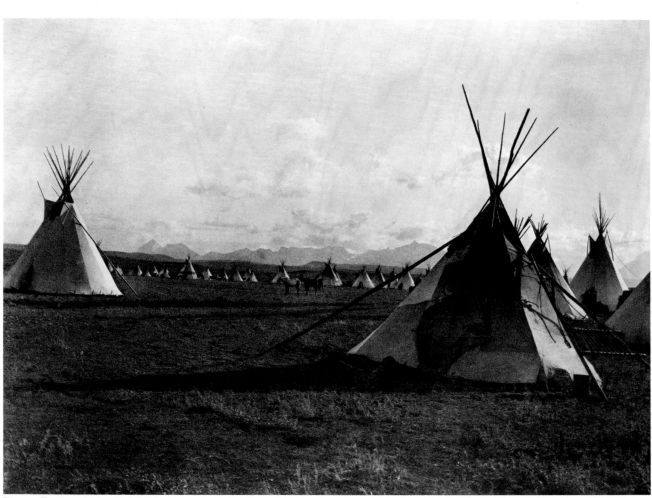

Piegan, *Encampment*

Everything the Power of the World does is done in a circle. The sky is round, and I have heard that the earth is round like a ball, and so are all the stars. The wind, in its greatest power, whirls. Birds make their nests in circles, for theirs is the same religion as ours. The sun comes forth and goes down again in a circle. The moon does the same, and both are round. Even the seasons form a great circle in their changing, and always come back again to where they were. The life of a man is a circle from childhood to childhood, and so it is in everything where power moves. Our tepees were round like the nests of birds, and these were always set in a circle, the nations hoop, a nest of many nests, where the Great Spirit meant for us to hatch our children. Black Elk, Oglala Sioux

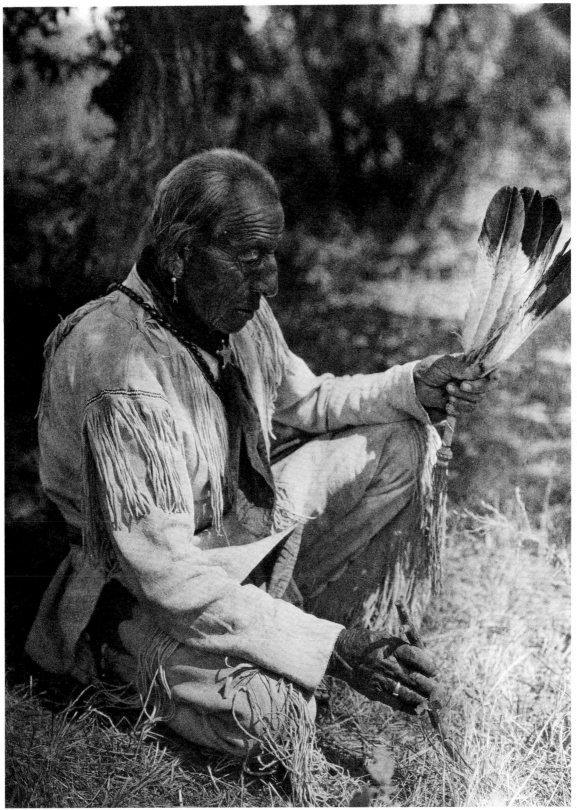

Cheyenne, *The Story of the Washita*

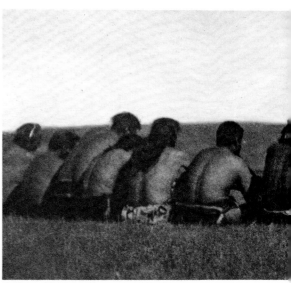

Arikara, *Medicine Ceremony—The Prayer*

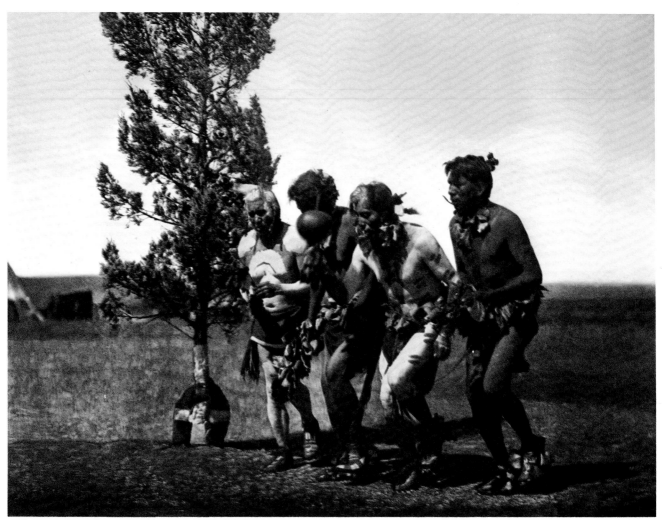

Arikara, *Medicine Ceremony—Dance of the Black-Tail Deer*

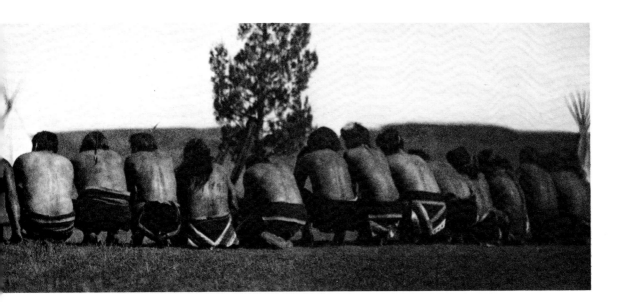

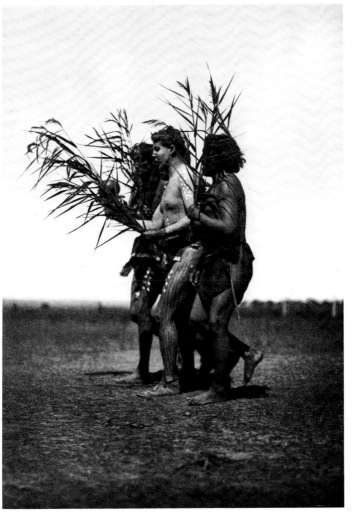

Arikara, *Medicine Ceremony—The Ducks*

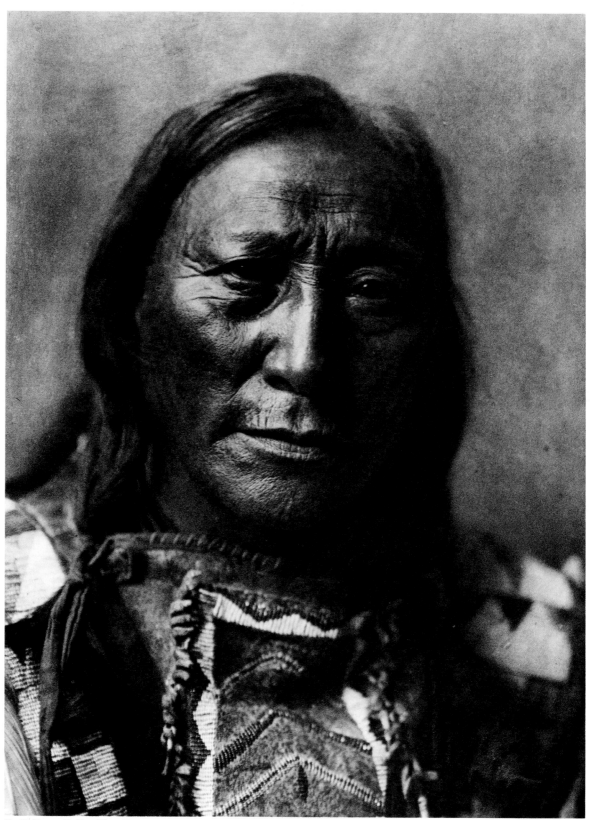

Brulé Sioux, *Hollow Horn Bear*

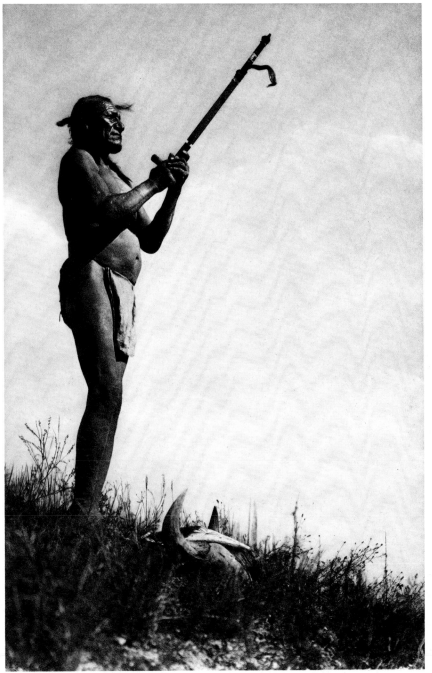

Oglala Sioux, *Prayer to the Mystery*

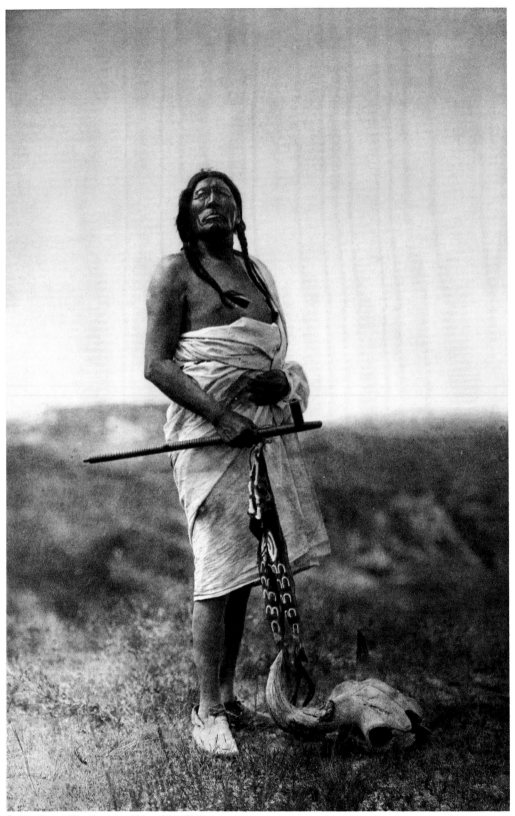

Oglala Sioux, *The Medicine Man—Slow Bull*

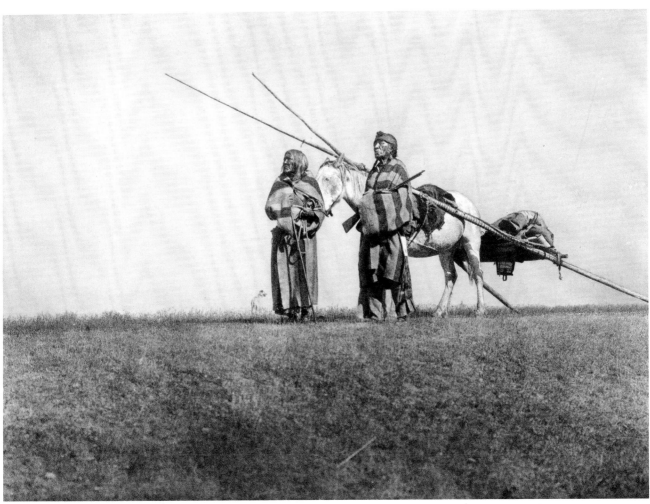

Blackfoot, *A Travois*

...*I am all the forces and objects with which I come in contact. I am the wind, the trees, and the birds, and the darkness.* Patty Harjo, *Who Am I?*

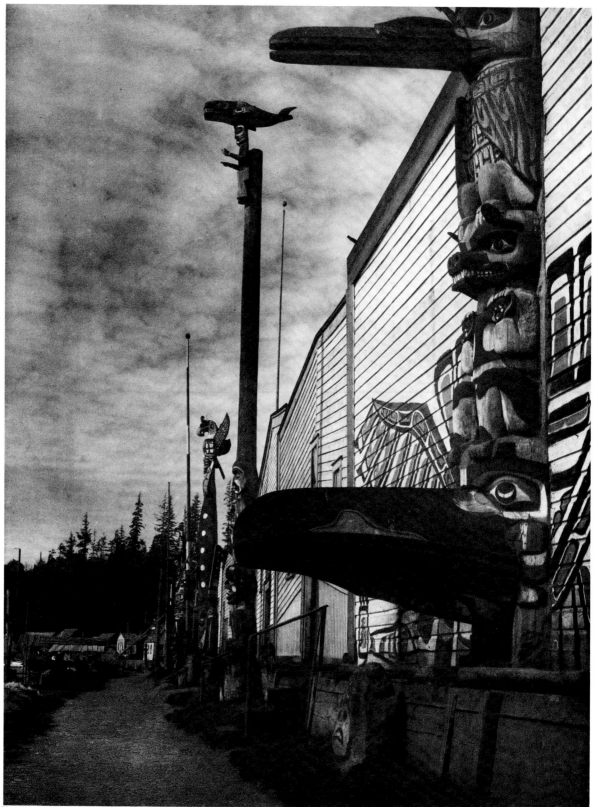

Kwakiutl, *Nimkish Village at Alert Bay*

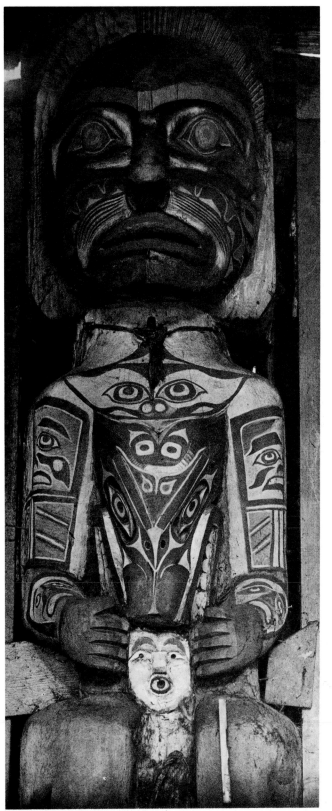

Kwakiutl, *Koskimo House-Post*

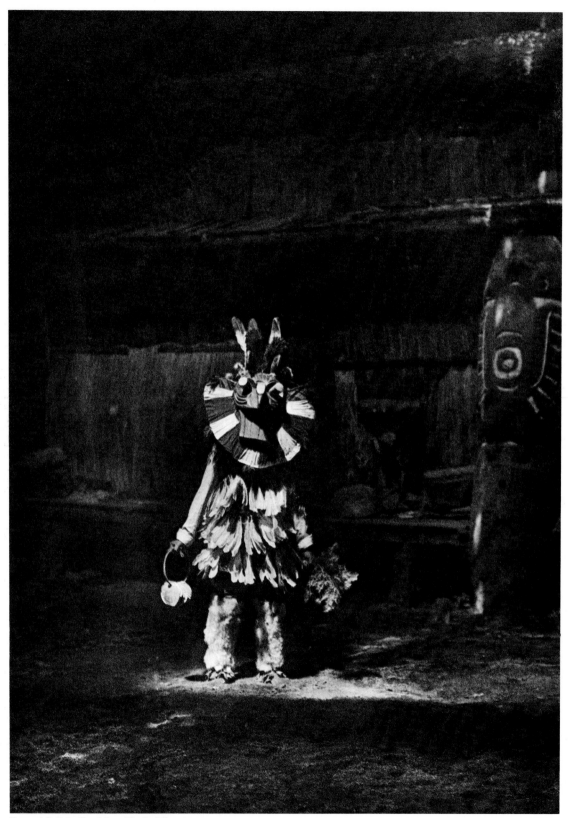

Coastal Salish, *Cowichan Masked Dancer*

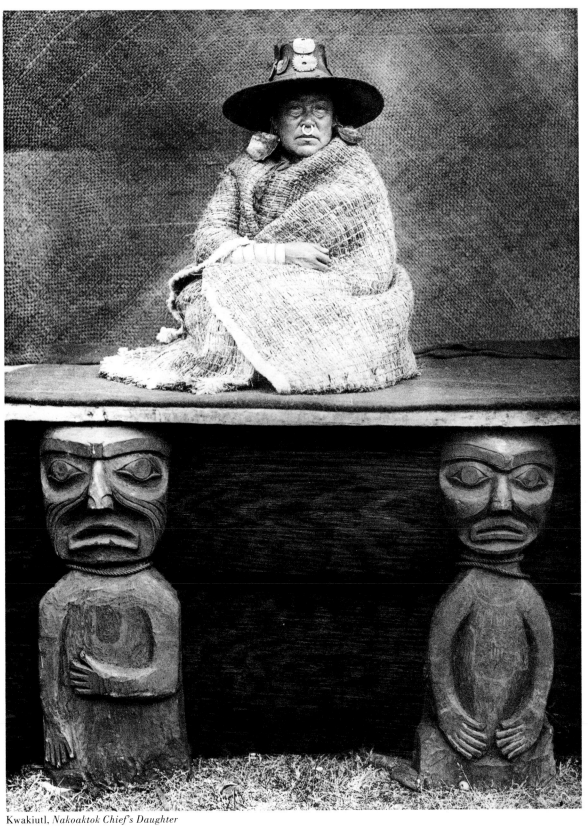

Kwakiutl, *Nakoaktok Chief's Daughter*

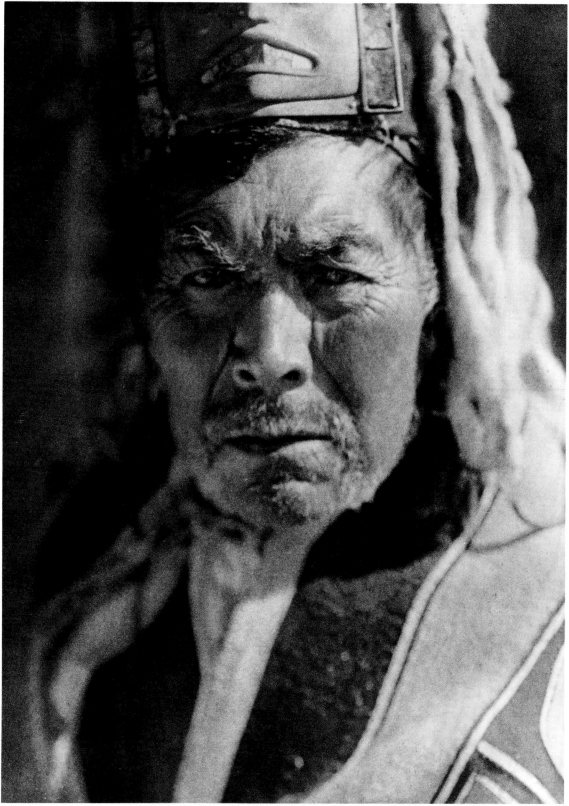

Haida, *Man of Massett*

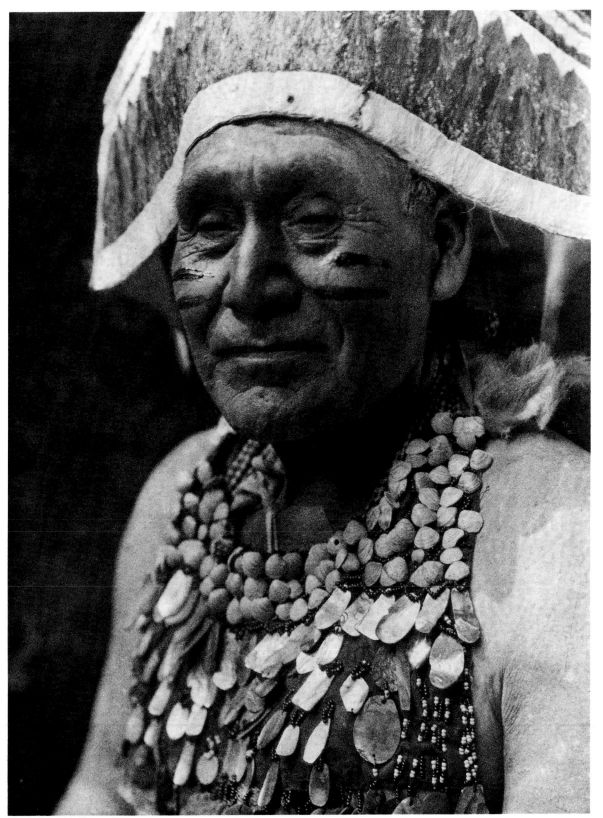

Hupa, *Jumping Dance Costume*

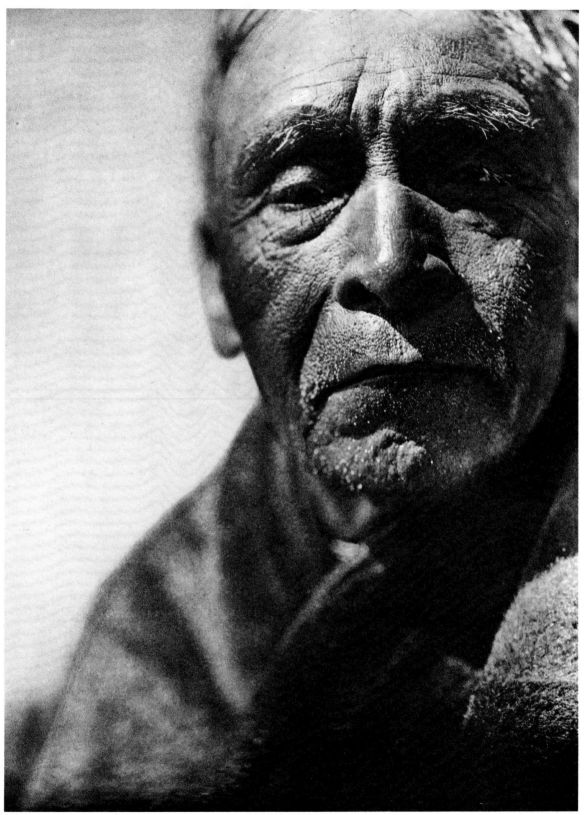

Wailaki

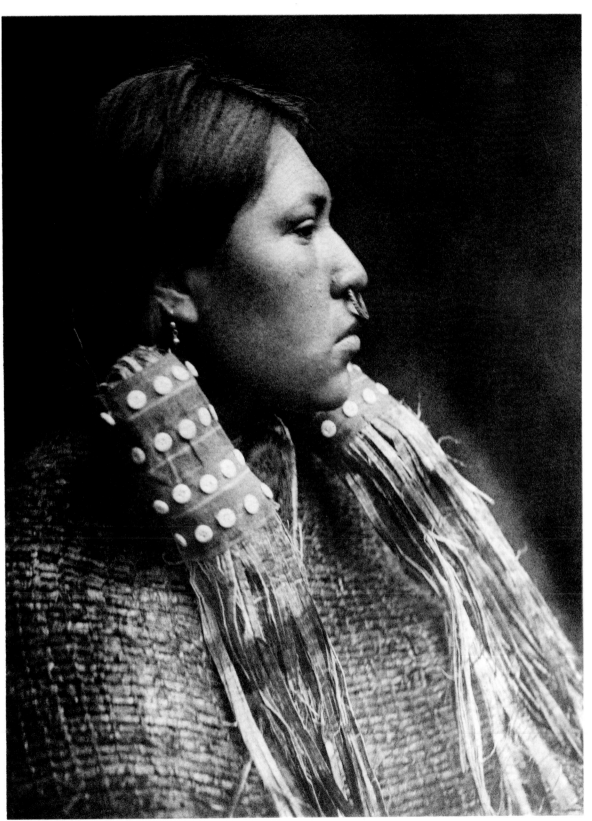

Hesquiat, *Maiden at Nootka*

We are two distinct races with separate origins and separate destinies. To us the ashes of our ancestors are sacred and their resting place is hallowed ground. You wander far from the graves of your ancestors and seemingly without regret...

But why should I mourn at the untimely fate of my people? Tribe follows tribe, and nation follows nation, and regret is useless...

But when the last Red man shall have become a myth among the White men...when your children's children think themselves alone in the field, the store, upon the highway, or in the silence of the pathless woods, they will not be alone. In all the earth there is no place dedicated to solitude. At night when the streets of your cities are silent and you think them deserted, they will throng with the returning hosts that once filled them and still love this beautiful land. The White man will never be alone.

Let him be just and deal kindly with my people, for the dead are not powerless. Dead—I say? There is no death. Only a change of worlds. Chief Seattle, speech to Governor Isaac Stevens in 1855 upon the signing of the Port Elliott Treaty. Seattle surrendered his lands on which the city of Seattle is now located, in return the Washington tribes were given a reservation.

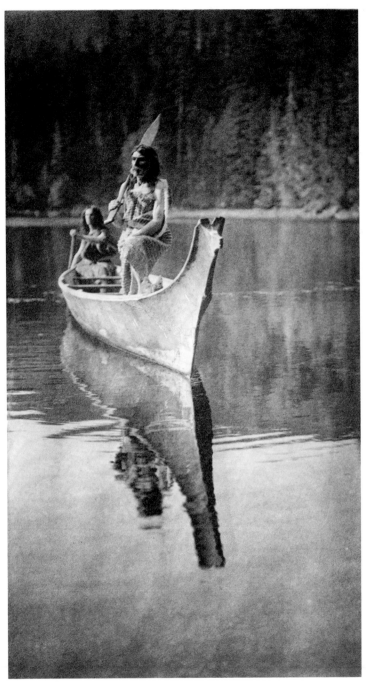

At Nootka

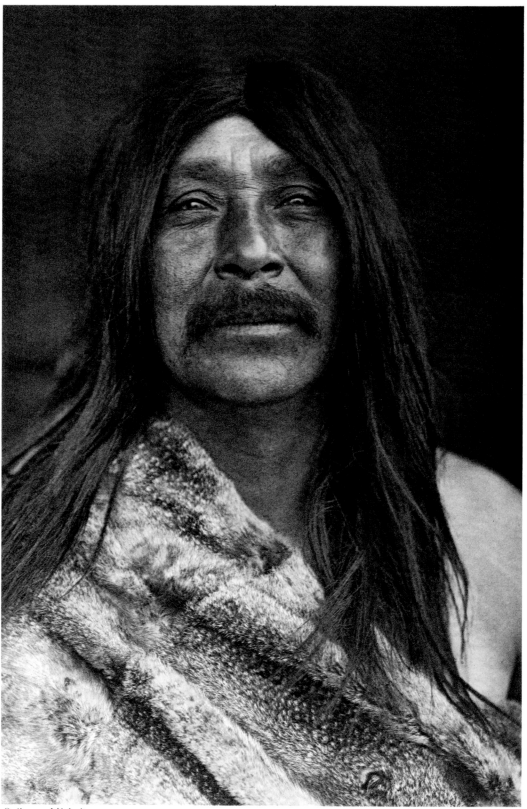

Quilcene, *Lélehalt*

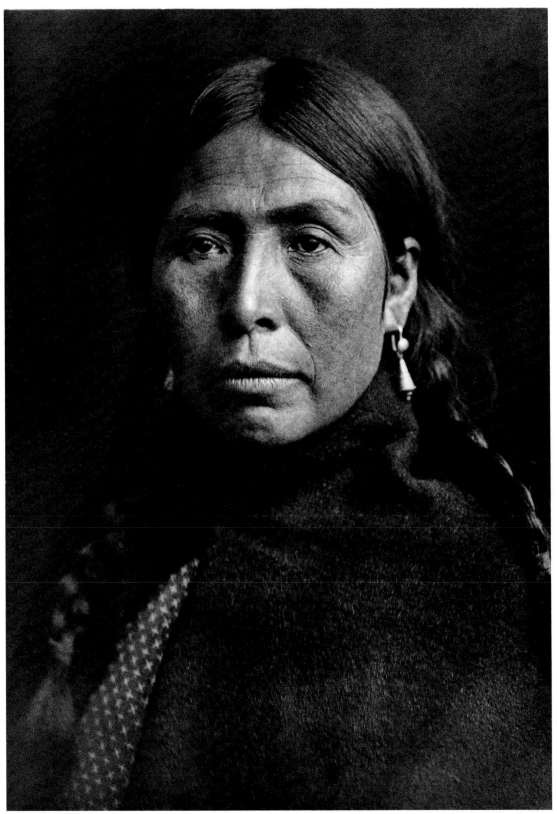

Coastal Salish, *Lummi Type*

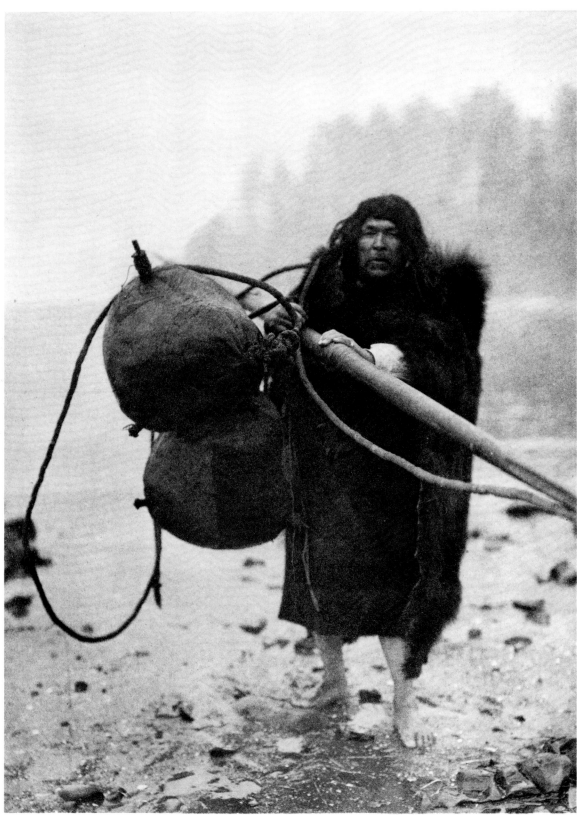

Makah, *The Whaler*

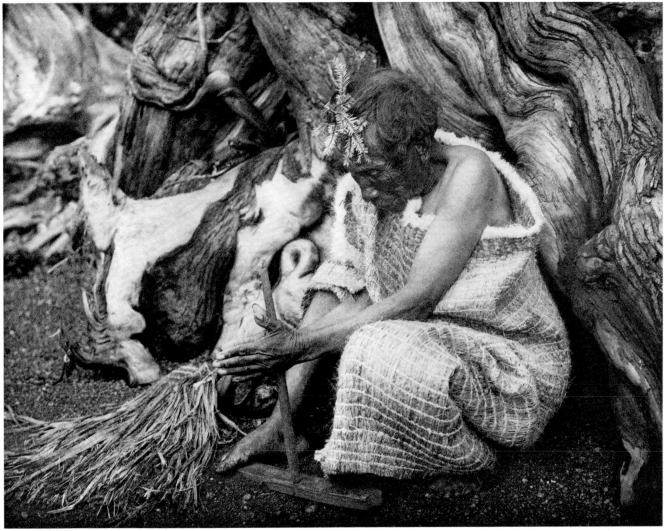

Kwakiutl, *Koskimo Fire Drill*

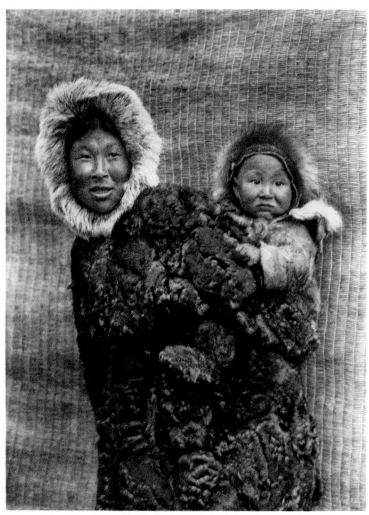

Eskimo, *Woman and Child at Nunivak*

My whole body is covered with eyes:
Behold it! Be without fear!
I see all around. Alaskan Eskimo Song

...the life of men and beasts does not end with death. When at the end of
life we draw our last breath, that is not the end. We awake to conscious-
ness again, we come to life again, and all this is effected through the
medium of the soul. Thus it is that we regard the soul as the greatest and
most incomprehensible of all. The Shaman, Aua, Iglulik Eskimo

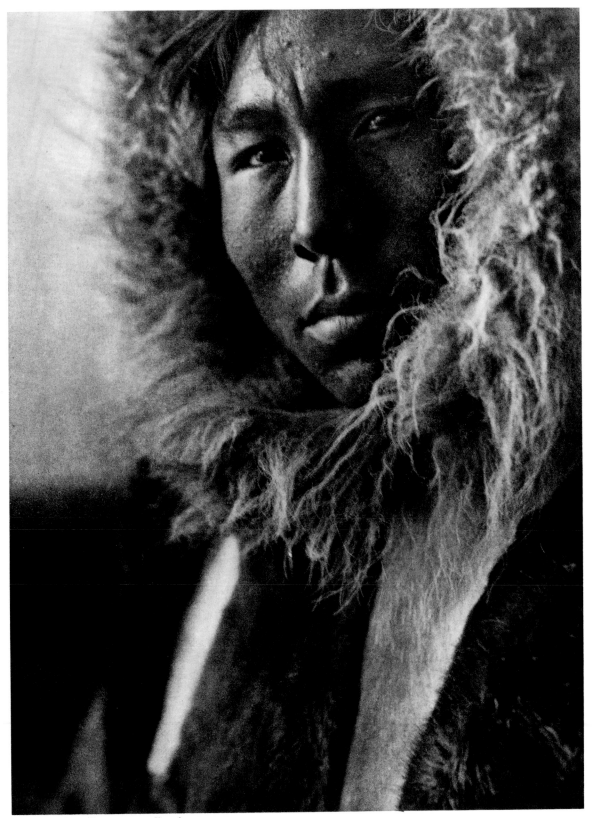

Eskimo, *Jackson, Interpreter at Kotzebue*

I have heard talk and talk, but nothing is done. Good words do not last long until they amount to something. Words do not pay for my dead people. They do not pay for my country, now over-run by white men. They do not protect my father's grave. They do not pay for my horses and cattle. Good words will not give me back my children. Good words will not make good the promise of your War Chief, General Miles. Good words will not give my people good health and stop them from dying. Good words will not get my people a home where they can live in peace and take care of themselves.

———

If the white man wants to live in peace with the Indian, he can live in peace. There need be no trouble. Treat all men alike. Give them the same law. Give them all an even chance to live and grow. All men were made by the same Great Spirit Chief. They are all brothers. The earth is the mother of all people, and all people should have equal rights upon it.

———

We are all sprung from a woman, although we are unlike in many things. We can not be made over again. You are as you were made, and as you were made you can remain. We are just as we were made by the Great Spirit, and you can not change us; then why should children of one mother and one father quarrel — why should one try to cheat the other? I do not believe that the Great Spirit Chief gave one kind of men the right to tell another kind of men what they must do. Chief Joseph of the Nez Percé, 1879

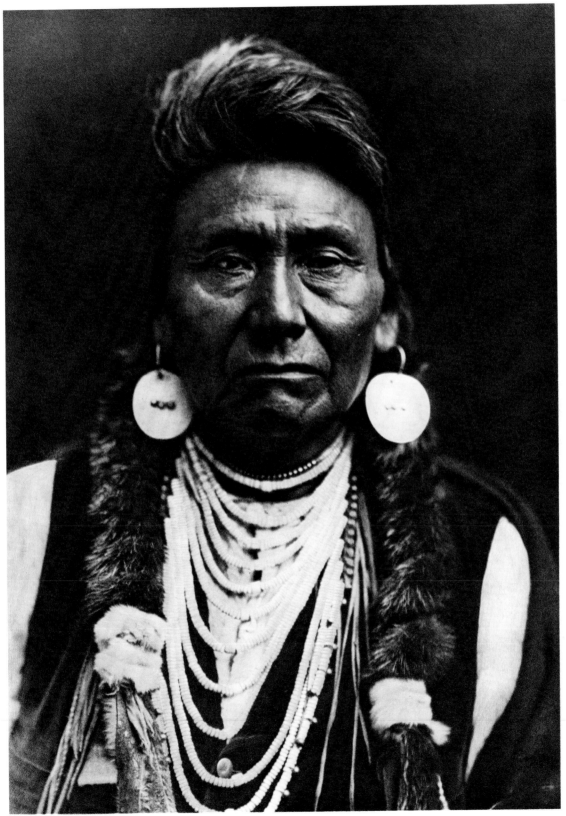

Nez Percé, *Chief Joseph*

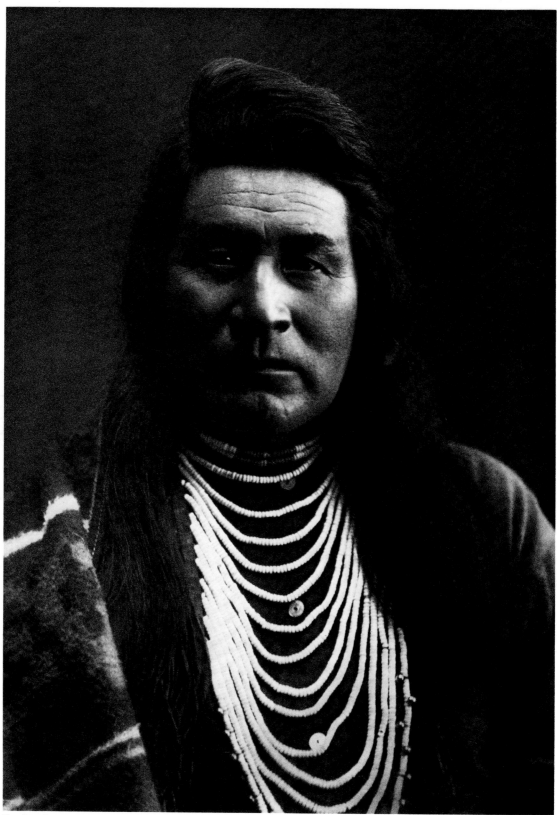

Nez Percé

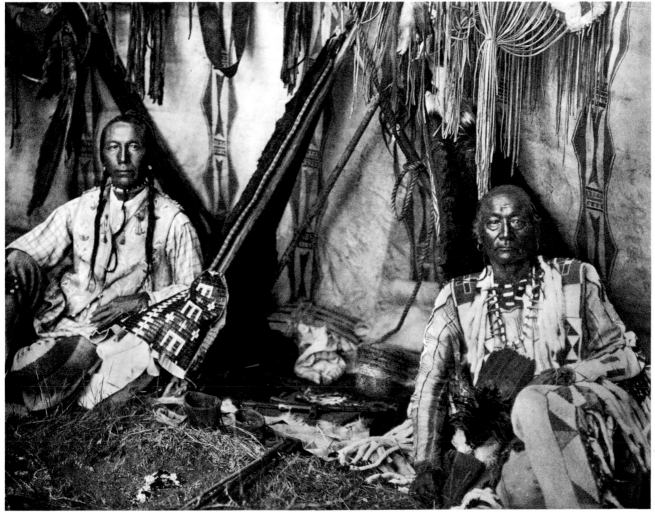

Piegan, *Lodge*

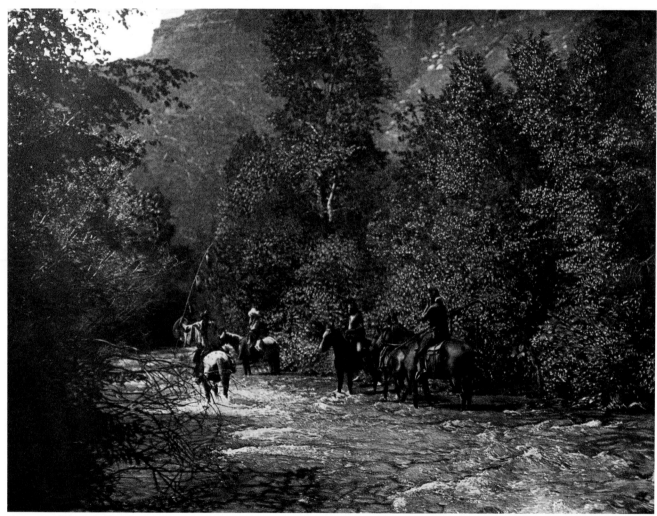

Apsaroke, *Mountain Fastness*

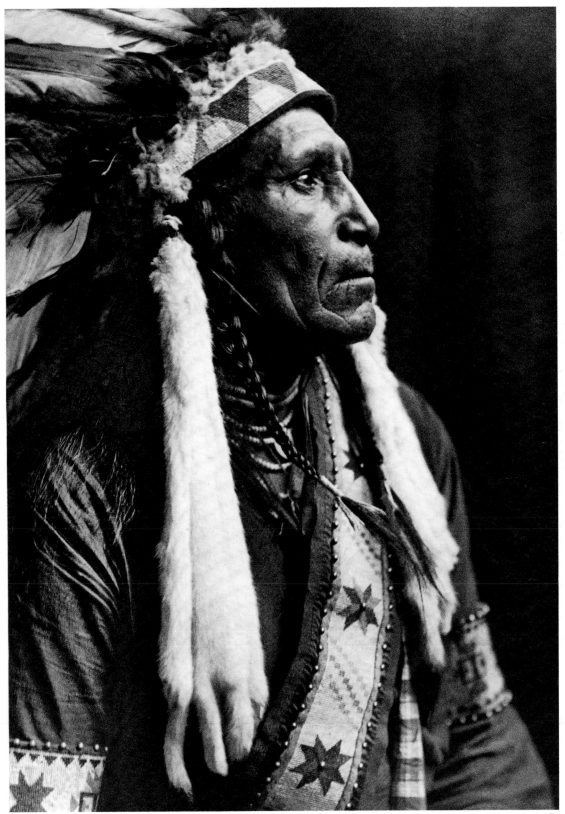

Nez Percé, *Raven Blanket*

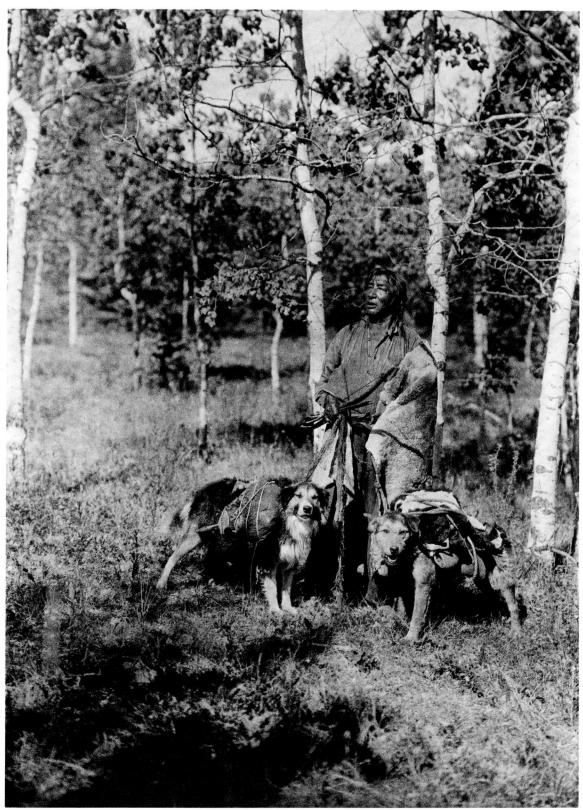

Assiniboin, *Hunter*

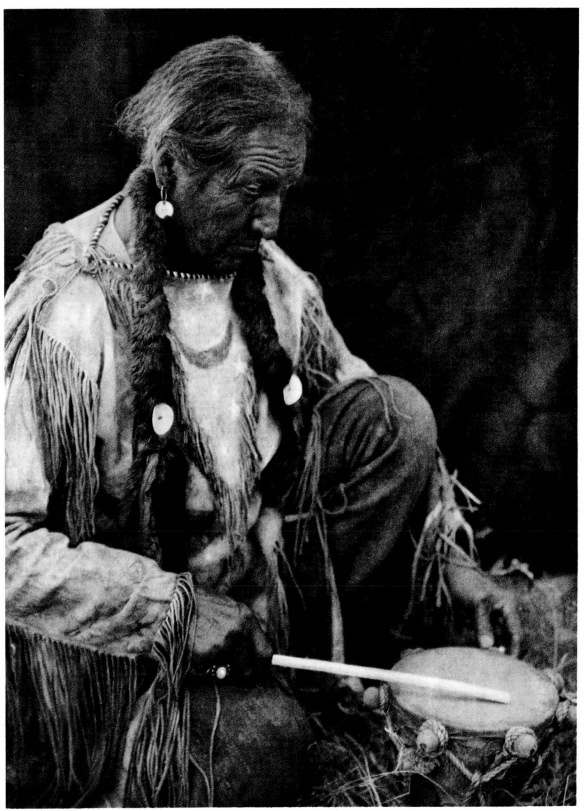

Peyote Drummer

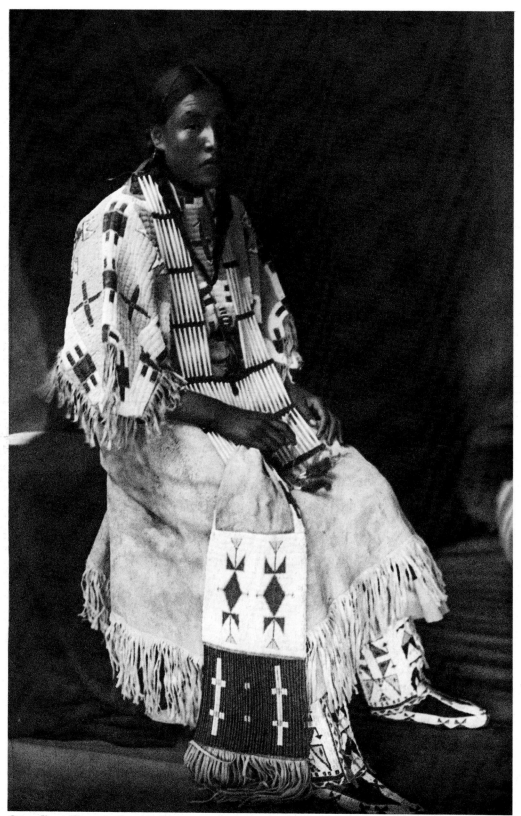

Sioux, *Young Woman in Deerskin Dress*

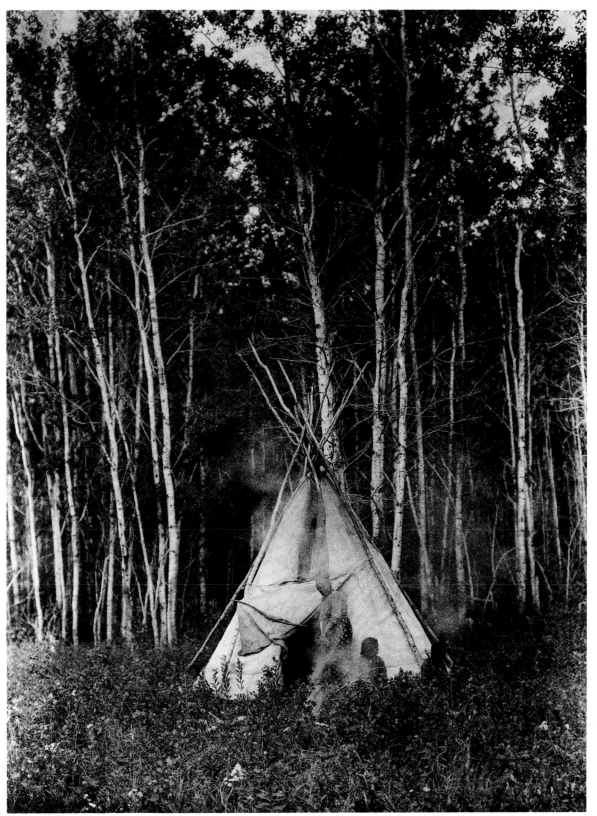

Chippewa, *Among the Aspens*

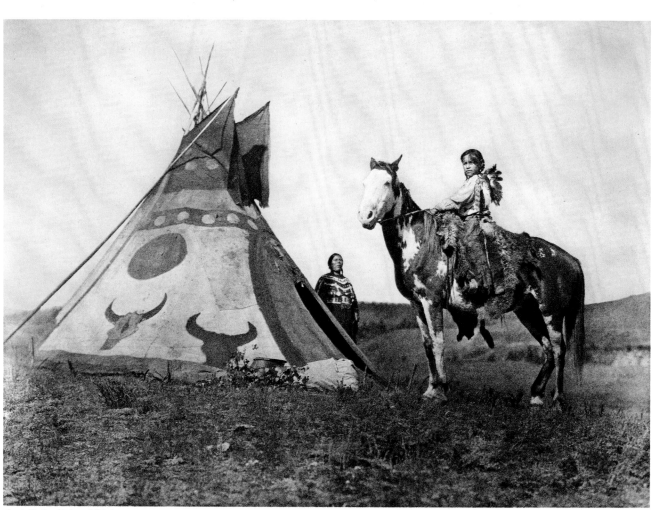

Assiniboin, *Painted Tipi*

out of the earth
I sing for them
a Horse nation
I sing for them
out of the earth
I sing for them
the animals
I sing for them

Teton Sioux, sung by Lone Man
I Sing for the Animals

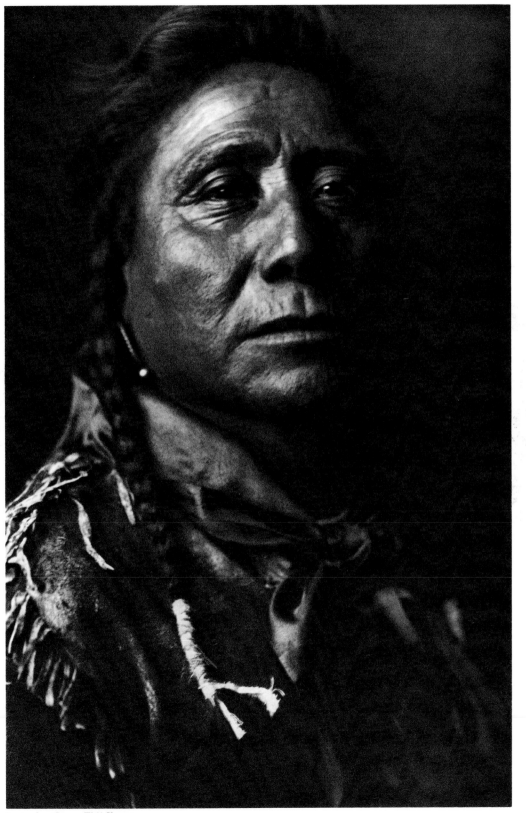

Apsaroke, *Coups Well-Known*

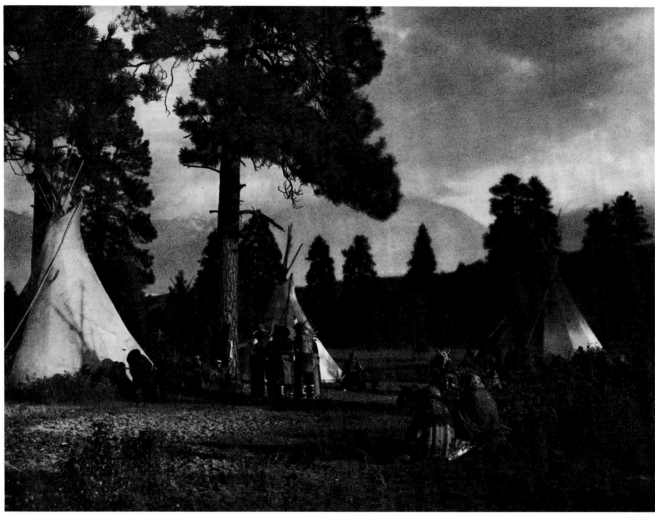

Interior Salish, *Flathead Camp on Jocko River*

We did not think of the great open plains, the beautiful rolling hills, and winding streams with tangled growth as wild. Only to the white man was nature a wilderness and only to him was the land infested with wild animals and savage people. To us it was tame. Earth was bountiful and we were surrounded with the blessings of the Great Mystery. Not until the hairy man from the east came and with brutal frenzy heaped injustices upon us and the families we loved was it wild for us. When the very animals of the forest began fleeing from his approach, then it was for us that the Wild West began. Luther Standing Bear, Sioux Chief

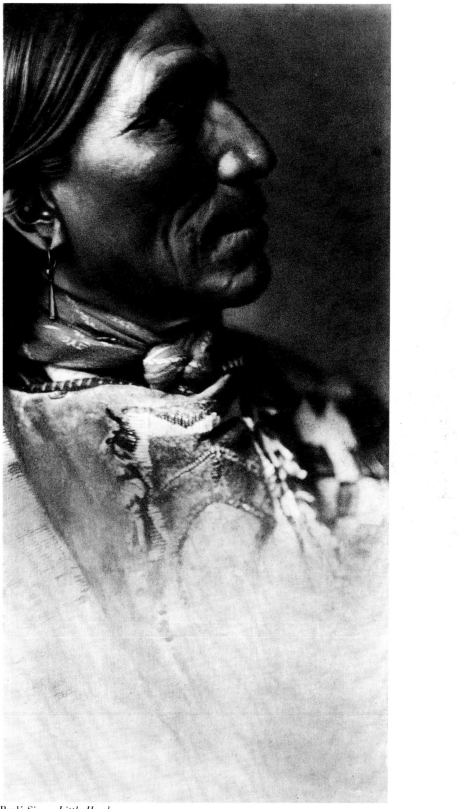

Brulé Sioux, *Little Hawk*

My sun is set. My day is done. Darkness is stealing over me. Before I lie down to rise no more I will speak to my people. Hear me, for this is not the time for me to tell a lie. The Great Spirit made us, and gave us this land we live in. He gave us the buffalo, antelope and deer for food and clothing. Our hunting grounds stretched from the Mississippi to the great mountains. We were free as the winds and heard no man's commands. We fought our enemies, and feasted our friends. Our braves drove away all who would take our game. They captured women and horses from our foes. Our children were many and our herds were large. Our old men talked with spirits and made good medicine. Our young men hunted and made love to the girls. Where the tipi was, there we stayed, and no house imprisoned us. No one said, "To this line is my land, to that is yours." Then the white man came to our hunting grounds, a stranger. We gave him meat and presents, and told him go in peace. He looked on our women and stayed to live in our tipis. His fellows came to build their roads across our hunting grounds. He brought among us the mysterious iron that shoots. He brought with him the magic water that makes men foolish. With his trinkets and beads he even bought the girl I loved. I said, "The white man is not a friend, let us kill him." But their numbers were greater than blades of grass. They took away the buffalo and shot down our best warriors. They took away our lands and surrounded us by fences. Their soldiers camped outside with cannon to shoot us down. They wiped the trails of our people from the face of the prairies. They forced our children to forsake the ways of their fathers. When I turn to the east I see no dawn. When I turn to the west the approaching night hides all. Statement of an aged Indian

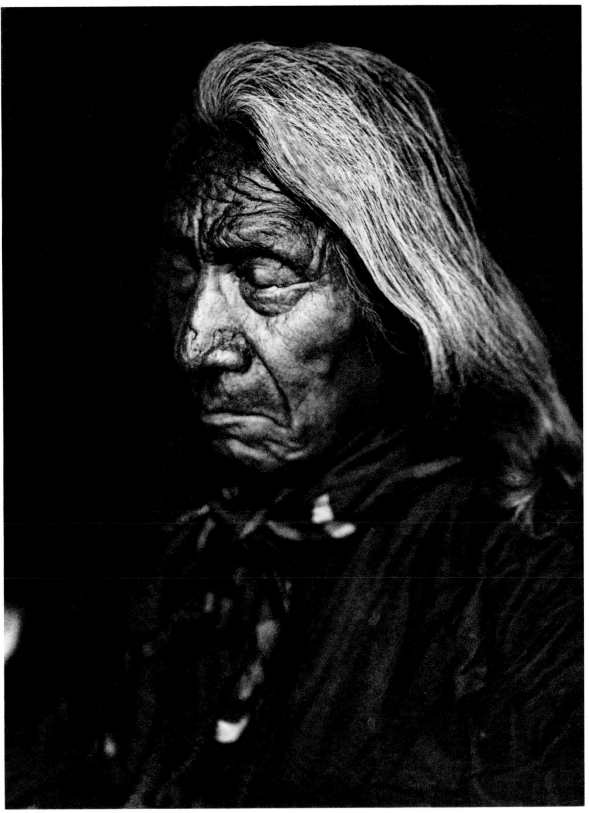

Oglala Sioux, *Red Cloud*

CAPTIONS AND NOTES

The following captions and notes for the photographs in this book were written by Edward S. Curtis for the portfolios of plates in the original edition of *The North American Indian.*

2 Tewa, *Offering to the Sun, San Ildefonso, 1925.*

18-19 Kutenai, *Duck Hunter, 1910.*

20 Keres, *At the Old Well of Acoma, 1904.* Members of Coronado's army of explorers in 1540 and Espejo in 1583 noted the *cisterns to collect snow and water* on the rock of Acoma.

21 Hopi, *A Walpi Man, 1921.*

22 Hopi, *Loitering at the Spring, 1921.* A group of Walpi and Hano girls in holiday attire. The background is a bit of Southwestern desert.

23 Hopi, *Watching the Dancers, 1906.*

24 Zuni, *Grinding Medicine, 1925.*

25 Keres, *A Paguate Entrance, 1925.*

26 Tewa, *Tablita Dancers and Singers, San Ildefonso, 1905.* The ceremony called Kohéye-hyárĕ *(tablita dance),* occurring in June and again in September, is characterized by public dancing and singing for the purpose of bringing rain clouds. The name refers to the wooden *tablets* worn by female dancers. In the plate the performers are dancing into the plaza, men and women alternating in pairs. At the right is the group of singers, their aged leader slightly in advance and the drummer at one side.

27 (Top) Hopi, *Buffalo Dance at Hano, 1921.* The Buffalo dance of the Upper Rio Grande pueblos was lately introduced among the Hopi, who attach no religious significance to it.

27 (Bottom) Hopi, *Snake Dancers Entering the Plaza, 1921.* At the right stand the Antelopes, in front of the snake-jars. The Snakes enter the plaza, encircle it four times with military tread, and then after a series of songs remarkable for their irresistible movement, they proceed to dance with the reptiles.

28 Tewa, *An Isleta Man, 1925.*

29 Tewa, *Francisca Chiwiwi, Isleta, 1925.* In general, an Indian regards his name as a personal possession, and does not willingly reveal it to strangers. Tact and experience usually overcome this reluctance, but in a brief visit to Isleta there seemed to be an understanding that no individual should admit the possession of a Tewa name. Only Spanish names were recorded.

30 Navaho, *Medicine Man—Hastobiga.*

31 Navaho, *The Blanket Weaver.* In Navaholand blanket looms are in evidence everywhere. In the winter months they are set up in the *hogans,* but during the summer they are erected outdoors under an improvised shelter, or, as in this case, beneath a tree. The simplicity of the loom and its product are here clearly shown, pictured in the early morning light under a large cottonwood.

32 Pomo, *Gathering Tules.* The round-stem tule, *scirpus lacustris,* was used principally for thatching houses, for making mats by stringing them laterally on parallel cords, and, securely lashed together in long bundles, in the construction of serviceable and quickly made canoes.

33 Hupa, *Mother and Child.*

34 Assiniboin, *Placating the Spirit of a*

Slain Eagle, 1926. For their feathers, which were used in many ways as ornaments and as fetishes, eagles were caught by a hunter concealed in a brush-covered pit. A rather elaborate ceremony took place over the bodies of the slain birds for the purpose of placating the eagle spirits.

35 Cheyenne, *Two Moons, 1910.* Two Moons was one of the Cheyenne war chiefs at the battle of Little Bighorn in 1876, when Custer's command was annihilated by a force of Sioux and Cheyenne.

36 Blackfoot, *Oksóyapiw, 1926.*

37 Apache, *Story-telling, 1903.*

38 Assiniboin, *Mosquito Hawk, 1908.*

39 Blackfoot, *Tipis, 1926.*

40 Arikara, *Bear's Belly, 1908.* A member of the medicine fraternity, wrapped in his sacred bear-skin.

41 Apsaroke, *Two Whistles, 1908.*

42 Piegan, *Two Medicine River, 1910.*

43 Oglala Sioux, *Slow Bull, 1907.*

44 Apsaroke, *Red Wing, 1908.*

45 Cheyenne, *Porcupine, 1910.* At summer gatherings for such occasions as the Sun Dance, the men sometimes protect their heads from the merciless sun by a thatch of cottonwood leaves.

46 Oto, *Old Eagle.* The medal worn by Old Eagle, in this case bearing the portrait of Lincoln, is like other medals given by the Government to noted chiefs from Washington's time.

47 Blackfoot, *Bear Bull.*

48 Apsaroke, *Shot in the Hand, 1908.*

49 Apsaroke, *Wolf, 1908.*

50 Piegan, *Encampment, 1900.*

51 Cheyenne, *The Story of the Washita, 1927.* An old Cheyenne warrior recounts the famous battle of the Washita in 1868 when the tribe was severely defeated by General Custer.

52 (Bottom) Arikara, *Medicine Ceremony—Dance of the Black-Tail Deer, 1908.* The dark figures are painted in a manner suggesting the elk, the others the antelope.

53 (Bottom) Arikara, *Medicine Ceremony—The Ducks, 1908.* Three members of the medicine fraternity, painted to represent ducks and holding the rushes among which waterfowl nest, in their dance around the sacred cedar.

52 & 53 Arikara, *Medicine Ceremony—The Prayer, 1908.*

54 Brulé Sioux, *Hollow Horn Bear, 1907.*

55 Oglala Sioux, *Prayer to the Mystery, 1907.* In supplication the pipe was always offered to the Mystery by holding it aloft. At the feet of the worshipper lies a buffalo skull, symbolic of the spirit of the animal upon which the Indians were so dependent. The subject of the picture is Picket Pin, an Oglala Sioux.

56 Oglala Sioux, *The Medicine Man—Slow-Bull, 1907.*

57 Blackfoot, *A Travois, 1926.*

58 Kwakiutl, *Nimkish Village at Alert Bay, 1914.* The figure at the bottom of the column in the foreground, with the painting on the front of the house, represents a raven. When a feast or a dance is to be held in this house, the guests enter through the raven's beak, the lower mandible of which swings up and down on a pivot. When a guest steps beyond the pivot, his weight causes the beak to clap shut, and thus the mythic Raven symbolically *swallows* the tribesmen one by one.

59 Kwakiutl, *Koskimo House-Post, 1914.* The huge, grotesquely carved, interior

supporting columns are the most striking feature of Kwakiutl houses. The figures perpetuate the memory of incidents in the legendary history of the family, frequently representing a tutelary spirit of the founder.

60 Coastal Salish, *Cowichan Masked Dancer, 1912.* The dancer impersonates one of the mythic ancestors who descended from the sky. Note the huge, carved house-post at the right.

61 Kwakiutl, *Nakoaktok Chief's Daughter, 1914.* When the head chief of the Nakoatok holds a potlatch (a ceremonial distribution of property to all the people), his eldest daughter is thus enthroned, symbolically supported on the heads of her slaves.

62 Haida, *Man of Massett, 1915.* The headdress is a *dancing hat*, and consists of a carved wooden mask surmounted by numerous sea-lion bristles and with many pendent strips of ermine skin.

63 Hupa, *Jumping Dance Costume, 1923.* The Jumping dance was an annual ceremony for averting pestilence. The headdress worn by the dancers was a wide band of deerskin with rows of red woodpecker crests and a narrow edging of white deerhair sewn on it. A deer skin robe was worn as a kilt, and each performer displayed all the beads and shells he possessed or could borrow. In the right hand was carried a straw-stuffed cylinder with a slit-like opening from end to end, an object the significance of which is unknown to the modern Hupa.

64 Wailaki, *1924.* The Wailaki were a group of loosely connected Athapascan bands occupying the watershed of the North fork of Eel River in northwestern California. About two hundred are now quartered with the Yuki on Round Valley reservation.

65 Hesquiat, *Maiden at Nootka, 1915.* The girl wears the cedar-bark ornaments that are tied to the hair of virgins on the fifth morning of their puberty ceremony. The fact that the girl who posed for this picture was the prospective mother of an illegitimate child caused considerable amusement to the native onlookers and to herself.

67 *At Nootka, 1915.*

68 Quilcene, *Lélehalt, 1912.*

69 Coastal Salish, *Lummi Type, 1899.*

70 Makah, *The Whaler, 1915.*

71 Kwakiutl, *Koskimo Fire Drill, 1914.*

72 Eskimo, *Woman and Child at Nunivak, 1928.*

73 Eskimo, *Jackson, Interpreter at Kotzebue, 1928.*

75 Nez Percé, *Chief Joseph, 1903.* The name of Chief Joseph is better known than that of any other Northwestern Indian. To him popular opinion has given the credit of conducting a remarkable strategic movement from Idaho to northern Montana in the flight of the Nez Percés in 1877. Their unfortunate effort to retain what was rightly their own makes an unparalleled story in the annals of the Indians' resistance to the greed of the whites. That they made this final effort is not surprising. Indeed, it is remarkable that so few tribes rose in a last struggle against such dishonest and relentless subjection.

76 Nez Percé.

77 Piegan, *Lodge, 1910.* Little Plume with his son Yellow Kidney occupies the position of honor, the space at the rear

opposite the entrance. The picture is full of suggestion of the various Indian activities. In a prominent place lie the everpresent pipe and its accessories on the tobacco cutting board. From the lodgepoles hang the buffaloskin shield, the long medicine-bundle, an eaglewing fan, and deerskin articles for accoutering the horse. The upper end of the rope is attached to the intersection of the lodge-poles, and in stormy weather the lower end is made fast to a stake near the center of the floor space.

78 Apsaroke, *Mountain Fastness, 1905.*
79 Nez Percé, *Raven Blanket, 1910.*
80 Assiniboin, *Hunter, 1926.*
81 *Peyote Drummer, 1927.*
82 Sioux, *Young Woman in Deerskin Dress, 1907.*
83 Chippewa, *Among the Aspens, 1926.* The Chippewa are one of several Athapascan groups occupying the territory between Hudson Bay and the Rocky Mountains, from about the fifty-seventh parallel to the Arctic Circle. Much of this area is barren, but the streams that feed and drain the innumerable lakes are bordered by thick groves of the slender, white boles of aspens, whose pleasant glades are favored by camps of fishermen and berry-pickers. The Chippewa dwelling, formerly made of the skins of caribou, on which animal these people principally depended for food, clothing, and shelter, was one of the few points in which their culture resembled that of the plains Indians. Their distinctive garment was a leather or fur coat with skirts cut to a point before and behind, a feature to which the appellation Wichip-wayaniwuk (*the pointed fur people*), the Cree original of Chippewa, alluded.

84 Assiniboin, *Painted Tipi, 1926.* A tipi painted with figures commemorative of a dream experienced by its owner is a venerated object. Its occupants enjoy good fortune, and there is no difficulty in finding a purchaser when after a few years the owner, according to custom, decides to dispose of it.

85 Apsaroke, *Coups Well-known, 1908.*
86 Interior Salish, *Flathead Camp on Jocko River, 1910.*
87 Brulé Sioux, *Little Hawk, 1908.*
89 Oglala Sioux, *Red Cloud, 1905.*
95 Navaho, *The Vanishing Race, 1904.*

CREDITS AND REFERENCES

12 (Introduction) Frithjof Schuon, *Light on the Ancient Worlds*, "The Shamanism of the Red Indians." London: Perennial Books, 1965, pp. 83-84.

14 The teachings of the Omaha Pebble Society as given by Wakidezhinga, an old leader. Quoted by Alice Cunningham Fletcher and Francis La Flesche, *The Omaha Tribe*. Washington: Government Printing Office, 1911, pp. 570-571.

15 Black Elk, Oglala Sioux. Told to Joseph Epes Brown, *The Sacred Pipe: Black Elk's Account of the Seven Rites of the Oglala Sioux*. Norman: University of Oklahoma Press, 1953, p. xx .

16 A Chief of the Oglala Sioux. Quoted by Alice Cunningham Fletcher, "The Elk Mystery or Festival: Oglala Sioux," *Reports of the Peabody Museum, Volume III (1880-1886)*. Cambridge: Salem Press, 1887, Sixteenth Report (1882), p. 276.

17 Tewa, *Song of the Sky Loom*. Herbert Joseph Spinden, ed. and transl., *Songs of the Tewa*. New York: Exposition of Indian Tribal Arts, 1933, p. 94.

34 Brave Buffalo, Teton Sioux. Quoted by Frances Densmore, *Teton Sioux Music (Bulletin of Bureau of American Ethnology, no. 61)*. Washington: Government Printing Office, 1918, p. 172.

40 Frances Densmore, *Teton Sioux Music (Bulletin of Bureau of American Ethnology, no. 61)*. Washington, D.C.: Government Printing Office, 1918, p. 71.

50 Black Elk, Oglala Sioux. Told to John G. Neihardt, *Black Elk Speaks*. New York: William Morrow & Co., 1932, pp. 199-200.

57 Patty Harjo. "Who am I?," Quoted in John Milton, "The American Indian Speaks," Dakota Press, 1969, p. 141.

66 Chief Seattle, speech to Governor Isaac Stevens in 1855 upon the signing of the Port Elliott Treaty. Compiled by W. C. Vanderwerth, *Indian Oratory*. Norman: University of Oklahoma Press, 1971, pp. 98-102.

72 Alaskan Eskimo Song. Edward Moffat Weyer, *The Eskimos: Their Environment and Folkways*. New Haven: Yale University Press, 1932, p. 401.

72 The Shaman, Aua, Iglulik Eskimo. Quoted in Knud Johan Rasmussen, *Intellectual Culture of the Iglulik Eskimos (Report of the Fifth Thule Expedition, 1921-1924, vol. 7, no. 1)*. Copenhagen: Gyldendalske Boghandel, Nordisk Forlag, 1929, pp. 60-61.

74 Chief Joseph of the Nez Percé, 1879. Chief Joseph, "An Indian's Views of Indian Affairs," North American Review, 1879.

84 Teton Sioux, sung by Lone Man, *I Sing for the Animals*. Quoted by Frances Densmore, *Teton Sioux Music (Bulletin of Bureau of American Ethnology, no. 61)*. Washington: Government Printing Office, 1918, p. 215.

86 Luther Standing Bear, Sioux Chief. Luther Standing Bear, *Land of the Spotted Eagle*. Boston and New York: Houghton Mifflin Co., 1933.

90 Statement of an aged Indian. Quoted in Clark Wissler, *Red Man Reservations*. New York: Macmillan (Collier Books), 1971, pp. 296-297. Originally published as *Indian Cavalcades*. New York: Sheridan House, 1938.

Grateful thanks to those publishers and individuals who have given their permission to reprint texts in copyright.

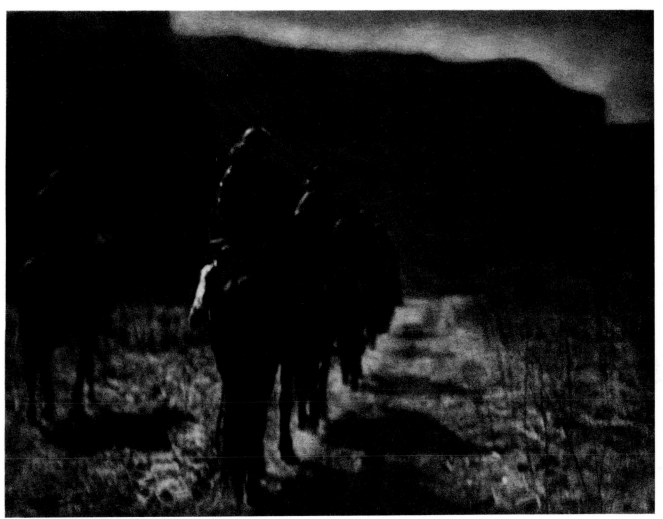

Navaho, *The Vanishing Race*